Ex Libris

Mastering Modern Calligraphy

Beyond the Basics: 2,700+ Pointed Pen
Exemplars and Exercises for Developing Your Style

MOLLY SUBER THORPE

ST. MARTIN'S GRIFFIN
NEW YORK

www.stmartins.com

Layout and cover design by Molly Suber Thorpe

Typefaces: Sagona by René Bieder and Proxima Nova by Mark Simonson

The Library of Congress Cataloging-in-Publication Data is available upon request.

ISBN 978-1-250-20699-2 (trade paperback)
ISBN 978-1-250-20700-5 (ebook)

Our books may be purchased in bulk for promotional, educational, or business use.
Please contact your local bookseller or the Macmillan Corporate and Premium
Sales Department at 1-800-221-7945, extension 5442, or by email at
MacmillanSpecialMarkets@macmillan.com.

First Edition: October 2019

10 9 8 7 6 5 4 3 2 1

Learn more about the author at mollysuberthorpe.com
Follow her on social media: @mollysuberthorpe

To Grace Mary and B.G.,
my grandmothers

CONTENTS

*Parsley, Sage,
Rosemary & Thyme*

*Typography is known for
two dimensional architecture
and every job requires extra zeal.*

*3852 West Dr.
Chicago, Illinois*

A B C D E F

Olive wood straight holder by Inkatable with vintage Italian nib; Rubato Pens handmade carrot oblique with Brause Steno 361 nib; Warm Ceramics pen rest; Strathmore vellum Bristol board; custom-mixed gray gouache; Koh-I-Noor Triograph 2B pencil; vintage French shipping label; Veto No. 1 paper clips; two vintage Italian nibs

MOLLY SUBER THORPE

Preface

This book is for calligraphers at every level who already have experience writing with a pointed pen.

Teaching pointed pen calligraphy for many years has allowed me to identify the learning tools beginner, intermediate, and professional modern calligraphers really want, and which ones are particularly hard to find. My goal in writing this book has been to bridge the gap between exemplar books of old and practice books by modern lettering artists. Unlike the classic penmanship guides from the past few centuries, this book's focus is on *modern* pointed pen styles, emphasizing fun experimentation over rigid uniformity. The result is a book brimming with exercises and exemplars that will not only help you master tricks of the trade, but develop your very own modern calligraphy style.

The lessons progress in difficulty, starting with pencil warm-ups, stroke drills to practice again and again, and a breakdown of the components of modern script. Following these lessons are over one thousand letterform and ligature variations—simple and florid—to copy freehand or trace; step-by-step guidance for refining your unique lettering style; exercises in flourished layout design; flourishing exemplars, from drills to decorations; and more than a dozen lettering guide sheets.

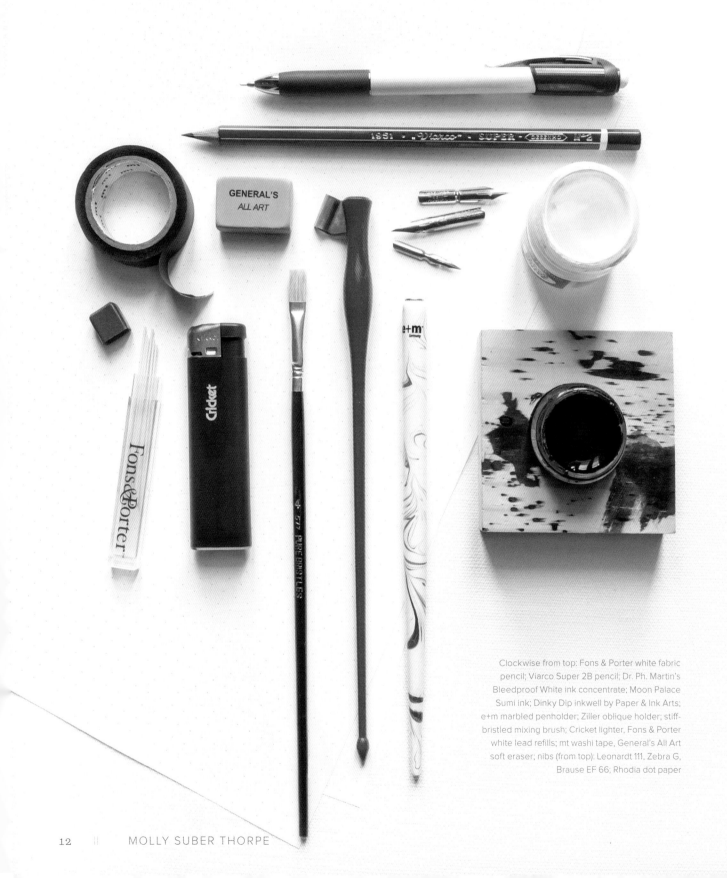

Clockwise from top: Fons & Porter white fabric pencil; Viarco Super 2B pencil; Dr. Ph. Martin's Bleedproof White ink concentrate; Moon Palace Sumi ink; Dinky Dip inkwell by Paper & Ink Arts; e+m marbled penholder; Ziller oblique holder; stiff-bristled mixing brush; Cricket lighter, Fons & Porter white lead refills; mt washi tape, General's All Art soft eraser; nibs (from top): Leonardt 111, Zebra G, Brause EF 66; Rhodia dot paper

What Makes Modern Calligraphy, Well, Modern?

Calligraphy is an umbrella term just about as broad as the word *painting*. When someone tells you she is a painter, you don't immediately know if her work is watercolor or oil, abstract or figurative, landscape or portraiture, etc. Likewise, a calligrapher can employ a wide range of media and styles: pointed pen, broad tip, or brushes; ink or paint; traditional styles or unorthodox ones; gilded manuscripts on vellum or place cards on seashells.

Thus, I define the term *modern calligraphy* quite loosely. It is not limited to any particular style, media, or application. For me, modern calligraphy is that which breaks with tradition and reveals the calligrapher's personal aesthetic strongly in the work.

Breaking with tradition can mean using traditional tools, such as pointed pens, in combination with unconventional media, like neon paint instead of ink, or tree leaves instead of paper. It can mean taking the letterforms of traditional styles, like Copperplate, and pushing them in new directions, sometimes even abstracting them to blur the line of legibility.

— Molly Suber Thorpe

Mastering Modern Calligraphy

Brause, EF 66 nib; Deleter Comic Penholder;
Moon Palace Sumi ink; Paper & Ink Arts
Copperplate Practice Paper

CHAPTER ONE

Methods for Effective Practice

The following chapter is all about how to get the most benefit from this book, including methods for effective practice and all the rules you should feel perfectly fine breaking. I also share the pens, ink, and paper that are popular among modern calligraphers, including my personal favorites.

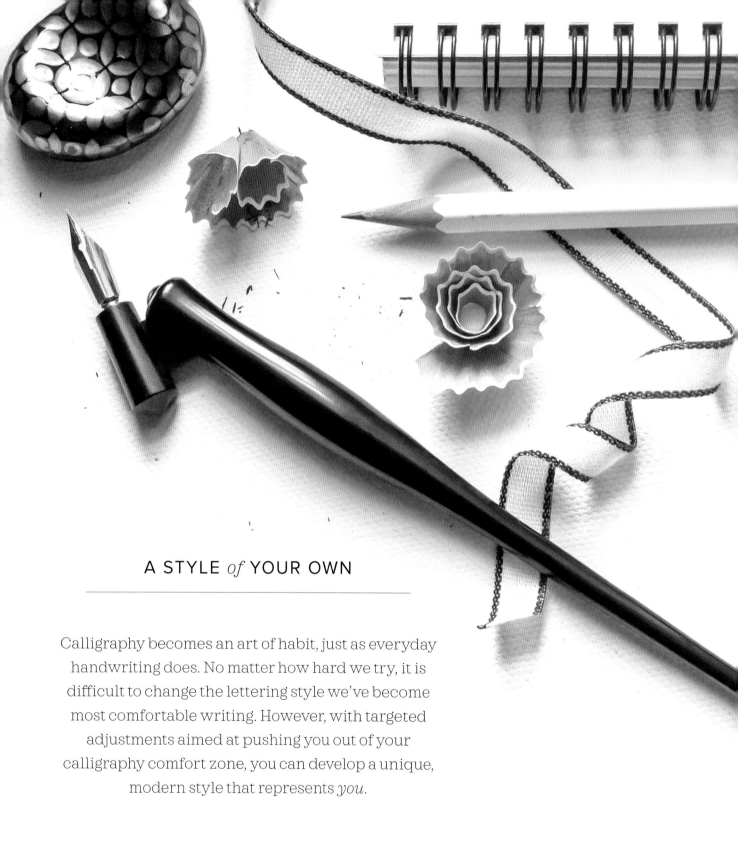

A STYLE *of* YOUR OWN

Calligraphy becomes an art of habit, just as everyday handwriting does. No matter how hard we try, it is difficult to change the lettering style we've become most comfortable writing. However, with targeted adjustments aimed at pushing you out of your calligraphy comfort zone, you can develop a unique, modern style that represents *you*.

Leonardt 111 EF nib; Speedball Oblique penholder;
MD Paper pencil; Studio Carta ribbon; Japanese
chopstick rest used as a pen rest

The most effective way to mold your lettering into a distinctive style you love is by questioning every stroke you make. Doing this requires an understanding of the components of every letterform and the overarching design principles that combine to give a calligraphic style its particular look and feel. If this seems overwhelming, don't worry—that's precisely what this book is about.

BREAK IT DOWN

The first step in creating a unique lettering style is analyzing the way you already write. Find a sample of your recent calligraphy, spread it out in front of you, and begin breaking it down letter by letter. Describe the shape of each letter to yourself, and compare the letters to one another. For example, you might find that the overturns of your *m* tend to be different heights, and the width of the counters within the *m* vary dramatically. (For a breakdown of letter anatomy, refer to page 25.) Maybe the cross stroke of your *t* looks different every time, or maybe it always looks the same. Do you write on a consistent baseline or do your words feel like they dance across the page? You may notice that some of your lowercase letters are consistently smaller than the rest, or that your uppercase letters are huge in proportion to their lowercase counterparts.

Do this exercise until you have evaluated your current style as much as you possibly can. You will probably come to understand that just as much—if not more—of the formation of the letters was dictated by unconscious habit as by conscious choice.

Next, step back and define your existing, overall style on both technical and stylistic levels, even if you're still a beginner. Does your calligraphy have a formal air? If so, why? Maybe it's narrow, heavily slanted, or closely based on a traditional style like Copperplate. Does it look playful? Again, why? Maybe the downstrokes are uneven thicknesses, the baseline is bouncy, or the letters don't seem to

complement one another. Perhaps it just looks uninspired and you're looking to infuse it with character. Still, pinpoint what it's lacking.

I recommend also doing this exercise with the work of a calligrapher you admire. Don't settle for loving their work when you can figure out *why* you love it. This will train your critical eye to notice every subtle nuance and creative decision.

At this point you will be ready to practice with greater purpose than before, consciously implementing changes that contrast the technical and stylistic habits you've become comfortable with over time.

In the chapters that follow, we're going to break down letters and put them back together in as many ways as we possibly can. We're going to transform entire alphabets with a single adjustment. We'll play with italic slants, baselines (or lack thereof), flourishing, weight, and proportion. And I'm giving you hundreds (and *hundreds*) of examples that you can use as a basis for your practice.

GROUND RULES

Before diving into this exciting world of tailor-made letterforms, I have just two important ground rules:

1. When bending the rules, bend them *a lot*. Shove yourself out of the nest. You can always circle back to where you started, but you might be surprised by just how much you like something completely new and different. When you make these big changes and find a new style you love, *then* you can go back and finesse the curves and proportions.

2. Don't be afraid to make ugly calligraphy. When you take the time to reconsider each and every element of a letterform, it's inevitable that some of the results will be, well, unappealing. But that is as important a part of the process as figuring out letterforms you *do* love.

If you break with tradition (a term I far prefer over "break the rules") then do so with intention. Presented here are the chief principles important in modern calligraphy to experiment with as you search for your own unique style. All the letter variations in this book explore one or more of these principles.

Overall size: Enlarge or shrink your writing to break out of your comfort zone. If you've stuck with the same letter size since the very beginning, make yourself a new baseline grid (or use one from Appendix I) and push yourself to draw much larger or smaller letters than you typically do.

Double letters: Break up uniformity by making sure double letter pairs are different, not the same.

Parallel strokes: Do away with parallel downstrokes within individual letters that have multiple straight downstrokes, such as *H, h, m,* and *n.* Rather than change just the slant of these strokes, try curving one or more of them.

Baseline bounce: Shift some letters above the baseline and some connector strokes below it. This single change, when done with intention, has a dramatic impact, creating a dancing effect across the page.

Letter width: Widen or narrow letters that appear out of proportion to the rest of the alphabet. Making bowls too wide is a common problem for beginners, but narrowing these letters (especially *a, b, d, g, o, p, q*) until they harmonize with the rest of the alphabet will give the whole style more elegance.

Boldness: Thicken or lighten the swells of downstrokes to instantly infuse any style with new flavor. This can be achieved either through adjusting pressure or changing to a more or less flexible nib.

Ascender height: Vary the heights and styles of your ascenders. Remember that the ascender height and the cap height (of your capital letters) do not have to be the same, so you can vary those, too.

Italic slant: Change the main slant of your whole alphabet (or vary it from one letter to the next for an especially playful look). Without changing the stroke pattern of a letter, a change in its axis has an immediate impact on its character. You can even experiment with a negative slant, called a "backhand" style.

Curve shape: Focus on the roundness of your curves and loops. Circular ones are playful and modern, whereas elliptical ones are traditional and tend to increase formality.

Flourish size: Just because they're decorative doesn't mean flourishes should be discreet. Most of the time, flourishes and loops can afford to be even bigger than we instinctively want to make them. A common issue I see in beginners' work is that their flourishing is too small, resulting in imbalanced letterforms.

Descender length: Vary the length and styles of your descenders. If you already mix up your descenders (or ascenders), try the opposite: make them all a uniform length and style.

Proportion: Have fun with letters' internal proportions, especially in uppercase. Some letters have repeated elements that can either be enlarged at the top or at the bottom. Others can be wider on the left or right. Some good examples include *B, E, f, K, k, M, m, N, n, P, R, S, W,* and *w*.

Ratio of x-height to cap height: By simply changing the ratio of your uppercase and lowercase letters, you can immediately change the style's overall tone. The larger the difference between the two heights, the more formal the style tends to look; the smaller the difference, the more whimsical.

Connector strokes: Extend your connector strokes, even without changing the shapes of the letters, to transform a dense style into a loose, airy one.

By all means break the rules and break them beautifully, deliberately and well. That is one of the ends for which they exist. Robert Bringhurst

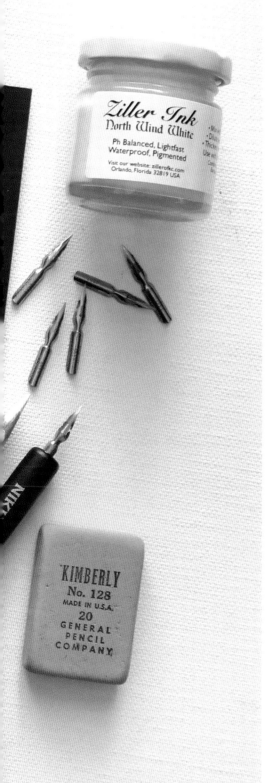

In his landmark book *The Elements of Typographic Style*, typographer and poet Robert Bringhurst famously wrote:

"A typographer determined to forge new routes must move, like other solitary travelers, through uninhabited country and against the grain of the land, crossing common thoroughfares in the silence before dawn. ... By all means break the rules and break them beautifully, deliberately and well. That is one of the ends for which they exist."

I carry these beautiful words with me in my own practice and urge you to do the same. Cross the "common thoroughfares" of calligraphic tradition into your own "uninhabited country." There you may find an artistic style that is truly yours.

Brause EF 66 nib; Nikko N-20 penholder; Ziller North Wind White ink; Paper Source cardstock

ANATOMY *of* THE GRID

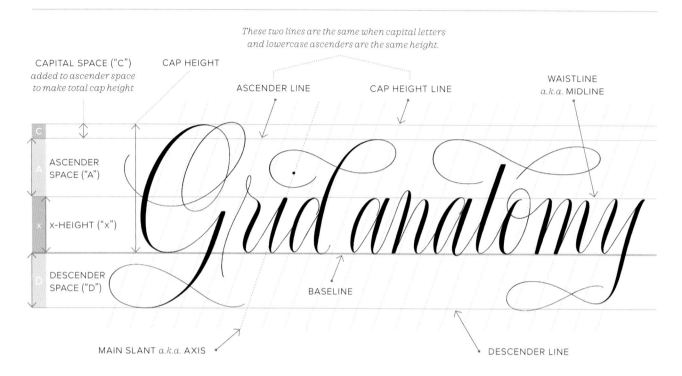

These two lines are the same when capital letters and lowercase ascenders are the same height.

CAPITAL SPACE ("C")
added to ascender space to make total cap height

CAP HEIGHT

ASCENDER LINE

CAP HEIGHT LINE

WAISTLINE
a.k.a. MIDLINE

ASCENDER SPACE ("A")

X-HEIGHT ("x")

DESCENDER SPACE ("D")

BASELINE

MAIN SLANT *a.k.a.* AXIS

DESCENDER LINE

Here is a small sampling of various grid layouts. Appendix I contains full-page versions of these grids and more, which you can trace or photocopy for personal use. The ratios listed are C:A:x:D (unless cap height and ascender height are the same, in which case C is left out).

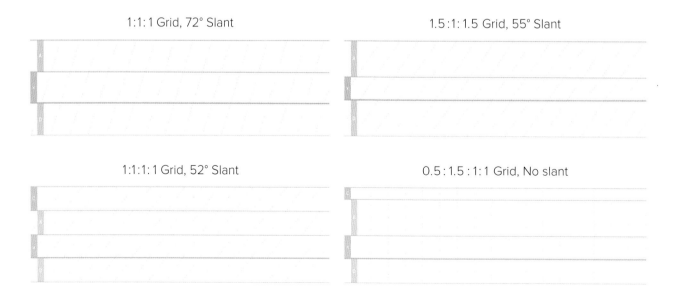

1:1:1 Grid, 72° Slant

1.5:1:1.5 Grid, 55° Slant

1:1:1:1 Grid, 52° Slant

0.5:1.5:1:1 Grid, No slant

CALLIGRAPHIC STROKES

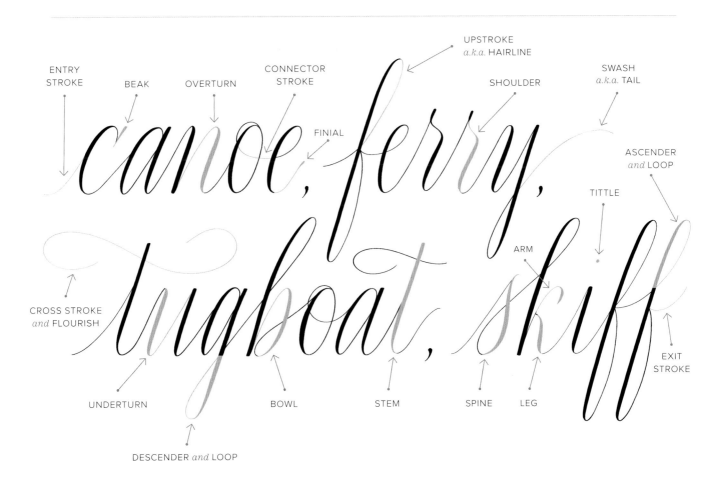

ENTRY STROKE · BEAK · OVERTURN · CONNECTOR STROKE · FINIAL · UPSTROKE *a.k.a.* HAIRLINE · SHOULDER · SWASH *a.k.a.* TAIL · ASCENDER *and* LOOP · TITTLE · ARM · CROSS STROKE *and* FLOURISH · UNDERTURN · DESCENDER *and* LOOP · BOWL · STEM · SPINE · LEG · EXIT STROKE

LETTER SPACES

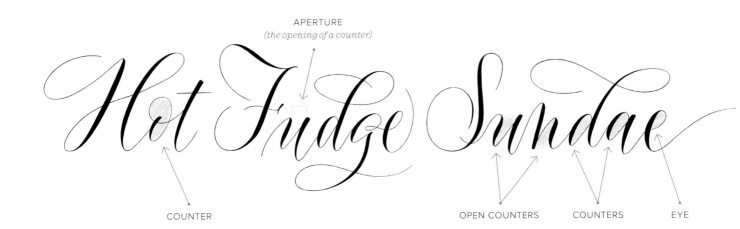

APERTURE
(the opening of a counter)

COUNTER · OPEN COUNTERS · COUNTERS · EYE

A GUIDE *to* SUPPLIES

You only need the very basic supplies to practice the exemplars and exercises in this book: a handful of nibs, your favorite penholder, good ink, and quality practice paper. Additional supplies, such as artist pencils and a lightpad, can be helpful, too.

No amount of technical skill can fully compensate for bad tools, so investing in high-quality supplies will set you up for the best possible outcome. For those who need some guidance in choosing the best tools, I share some of my own favorites here and, in Appendix III, provide many resources for buying them.

Pointed Dip Pen Nibs

If you have just dipped your toes in the ocean of pointed nibs, I highly recommend that you invest in a handful of them, ranging from very stiff to very flexible. Writing with different nibs is akin to driving different cars: the brakes, acceleration, maneuvering, size, and mileage vary dramatically from one to the next and most people need to test-drive quite a few before picking a favorite! Likewise, nibs vary dramatically in pressure sensitivity, sharpness, and shape. These factors dictate how thick its hairlines and downstrokes are, how often it needs to be re-inked, and how durable it is (i.e., how long it will last). For this reason, no single nib is universally beloved, although some are much more popular than others.

Most calligraphers end up having one or two favorite nibs, but as I say, that preference should be borne from lots of experimentation. Ultimately the best nib for you will be the one that creates the thin and thick strokes you desire for your personal style and feels best in your hand.

There are so many pointed nibs on the market that choosing which ones to try can be overwhelming. To help you make an educated choice, I've created a chart of some of the most popular ones, ranging from stiffest to most flexible. (Note: "EF" in the names of some nibs stands for "extra fine.")

If you're not very experienced, then you should start with one on the stiffer side—anything in the range from Zebra G to Nikko G. The stiffer the nib, the less finicky it is; the more flexible, the easier it is for the tines to separate with even a tiny bit of pressure, resulting in more snags and splatters. Don't be scared of the flexible nibs, though—lots of calligraphers fall in love with them on first try! (The Brause EF 66, while extremely small, sharp, and flexible, is my all-time favorite.)

If you have a light touch (meaning you don't naturally exert heavy pressure on your pen), then a stiff nib will yield low-contrast lettering: thin up-strokes and thin to medium downstrokes. To create a bold style, you could press down harder, but that's a recipe for hand cramps and pen snags. Better yet, simply switch to a more flexible nib that makes bold strokes with light pressure.

Maybe you're a person who naturally presses down hard on your pen. If so, check that you aren't gripping your pen too hard. (Even if you're not, it might be beneficial for you to practice a lighter touch just to avoid arm pain.) You won't need a very flexible nib to create relatively bold letters, but you might like one anyway because extra bold strokes can be so fun!

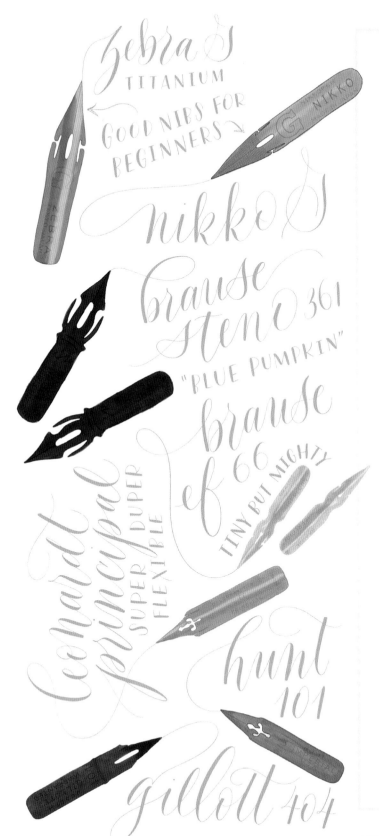

Popular Pointed Nibs

Zebra G
very stiff; very fine hairlines; medium swells

Tachikawa T-600 EF
very stiff; very fine hairlines; medium swells

Leonardt 111 EF
very stiff; fine hairlines; medium swells

Nikko G
stiff; fine hairlines; medium to heavy swells

Hunt 22B
somewhat flexible; fine hairlines; medium swells

Tachikawa G
somewhat flexible; fine hairlines; heavy swells

Brause Steno 361 ("Blue Pumpkin")
flexible; medium hairlines; heavy swells

Gillott 404
flexible; medium hairlines; heavy swells

Brause Rose
flexible; medium hairlines; extra heavy swells

Gillott 303
very flexible; very fine hairlines; heavy swells

Brause EF 66 ("Arrow")
very flexible; fine hairlines; very heavy swells

Hunt 101
very flexible; fine hairlines; very heavy swells

Leonardt Principal
extra flexible; very fine hairlines; very heavy swells

QUITE STIFF

VERY FLEXIBLE

THESE ARE A FEW OF MY

Favorite Things

two nice waterproof black options

opaque white

(JUST MIX WITH WATER)

(PLUS THE *matte* FINISH IS COOL)

*Sumi ink**

*MY FAVORITE FOR ALMOST EVERYTHING

in black &

vermilion

really great metallic colors

(ESPECIALLY GOLD)

SO VIBRANT!

ZILLER: A WHOLE LINE OF

beautiful water- proof colors

(INCLUDING WHITE)

Monoline Dip Pen Nibs

Get yourself at least one monoline dip nib if you're interested in trying the monoline styles in this book, or in making a variation of any other style using a uniform stroke weight. Some of these nibs can look at first glance like a regular pointed pen nib, but on closer examination you'll see that the very tip is turned upward, blunting it so that it's more resistant to pressure. Another style of monoline nib has a rounded, pancake-like tip and an attachment that serves as an ink reservoir, similar to those on broad tip nibs.

Monoline nibs are a fun addition to the toolkit of beginner and advanced calligraphers alike, but they can take a little getting used to. To achieve smooth strokes and ink flow, the angle of pen to paper may need to be adjusted from what you're used to with a pointed pen. Some monoline (and nearly monoline) nibs I really like are:

Brause B50 Pfannen
turned-up tip; thin, truly monoline stroke

Brause Redis Ornament
ink reservoir; truly monoline stroke; sizes 0.5–1.5mm

Manuscript Leonardt 300 Ballpoint
turned-up tip; creates slight swells with enough pressure

High-quality Ink

When doing drills and letterform practice, it's crucial that your ink doesn't slow you down. Good black inks are among the easiest to work with straight out the bottle. I recommend sumi ink for its opaque, rich black shade. There are lots of sumi brands but Moon Palace Sumi (pictured on the left) is my personal favorite. I give it to all my students and I use it myself for most of my work with black ink.

Sumi certainly isn't the only good black ink, though. Higgins Calligraphy ink is an economical (and waterproof!) choice great for all those hours of practicing. If it's waterproof *and* matte you're after, you can't go wrong with Dr. Ph. Martin's Black Star, although you have to transfer it into an ink pot because it comes in a dropper bottle. Iron gall ink is a very dense black, which makes it a good choice for calligraphy destined for reproduction.

White, colored, and iridescent inks are so much fun to use! My favorite whites are Dr. Ph. Martin's Bleedproof White and Ziller North Wind White. Both these brands also make beautiful colored inks. For a pop of red—or just a change from my usual black—I always use vermilion sumi ink, which is the most vibrant, beautiful shade of red-orange you'll ever see.

Penholders

To practice the exercises and exemplars in this book, you may want to use the penholder you're already most comfortable with, whether that's oblique or straight. If, however, you're ready for a new challenge, try a penholder very unlike the one you're accustomed to. For example, if you've been using a traditional-sized pen, try a "carrot" holder (which is much shorter and wider), or a comic pen with a thick rubber grip. Used to a straight holder? Then try an oblique, and vice versa. Just like test-driving new nibs, trying out a new tool can have thrilling results!

Handmade and custom penholders are beautiful gifts to give yourself and can potentially be a lot more comfortable to hold—but not always. If you suffer from chronic hand pain, you might invest in a handmade, ergonomic pen. If you use oblique pens, higher-end varieties can be custom-fitted to your favorite nib, and the flange's angle optimized for that very nib size. Appendix III has a long list of handmade pen makers.

That said, my straight, five-dollar, wooden penholder is what I reach for most often! I own lots of gorgeous handmade holders that I use on occasion, but for my writing habits and style, nothing beats these small, lightweight pens. So remember, just because a tool is more expensive, it isn't *necessarily* better suited to your needs.

Practice Paper

I recommend using translucent paper for tracing the exemplars in this book. You should also copy the shapes freehand, of course, but tracing helps many people build muscle memory, reinforcing the smallest details so that your hand learns to move more smoothly and confidently. I like Borden & Riley Layout Bond and Canson Vellum for this, but many traditional tracing papers will work, too, so long as they're untextured and your ink doesn't bleed through them.

While you can use tracing paper for freehand practice, too, you'll probably want something a bit heavier. Rhodia and Clairefontaine make paper that is great for practicing, but for many people, laserjet printer paper works quite well for practice, too. It's also an economical choice because you can purchase it by the ream.

Many companies sell calligraphy practice pads with grid lines printed on them. Look for ones specifically for script calligraphy, so that they have slanted lines as well as baselines. (Paper & Ink Arts' Copperplate Practice Pad is a nice one for practicing a steep slant.) Because I use many different grid designs, I print or copy mine and either tuck it under a sheet of translucent paper or use it with a lightpad.

For practicing on dark paper, I love Strathmore Artagain black pads, but many dark papers designed for charcoal and pastel drawing work for calligraphy.

Whatever paper you choose for your practice, be sure to keep at least a few sheets of paper under your top sheet, rather than put a single sheet down on a hard surface. This small amount of padding makes a big difference!

Paint

Watercolor and gouache can make beautiful replacements for ink. Gouache tends to be more opaque, with a matte finish. It comes in concentrated tubes and is easy (and fun) to mix. Whenever I need a custom color that has to be very vibrant and perfectly opaque, especially when it's a light color for dark paper, I reach for gouache. Schmincke Calligraphy and Winsor & Newton Designers gouaches are among the most popular for dip pen work.

You should always have gum arabic on hand when mixing gouache. As a binding agent, it helps color flow smoothly and also adds a glossy sheen.

Watercolor, depending on its consistency, ranges from translucent to opaque. You can use either concentrated tubes or jars of color, watered down to your liking, or apply it directly from the palette with a paintbrush. FineTec watercolor palettes are a favorite among calligraphers for their wide range of vibrant, iridescent colors.

Additional Supplies

GRAPHITE PENCILS
Soft artist pencils, ranging from 4B to 6B, are great for warm-ups and refining complex layouts.

WHITE PENCILS
For drawing baselines and sketching on dark paper, I prefer a mechanical white fabric pencil. These are

easily erasable without leaving indents or smudges. If impeccable erasability isn't so important for your practice, you can use a white charcoal pencil.

INK STIRRER

If you have an ink or paint mixture that separates easily, an ink stirrer can be a lifesaver. The magnetic varieties are hands-free and a great investment if you do a lot of work with metallic or glittery inks.

LIGHTPAD

A lightpad (also known as a light box) is entirely optional. Many calligraphers like using these because they are great for tracing exemplars and easily following guide sheets. Lightpads are also helpful for refining and editing your work.

I use a dimmable lightpad because the lowest light setting is easiest on my eyes. I also prefer those that are lightweight and USB-powered, making them easy to take on the road.

TABLE EASEL

Some calligraphers—but not all!—like writing pointed pen calligraphy on a slanted surface, even though that is traditionally reserved for broad tip calligraphy. If working with your paper flat on a desk is giving you trouble, try putting your paper on a table easel. Many companies make beautiful wooden ones with adjustable slants, and some with clip-on lamps. You can even put your lightpad on the table easel, too.

SCANNER

A good scanner is a necessity when you design calligraphy for reproduction, but you don't need the most expensive one on the market. Nearly all scanners can capture 300 ppi ("pixels per inch"), which is the only important feature for scanning at print-quality resolution. I usually scan at 600 ppi, though, so that I have the freedom to enlarge my artwork without pixelation.

You can find resources for buying supplies around the world, including custom and handmade tools, in Appendix III.

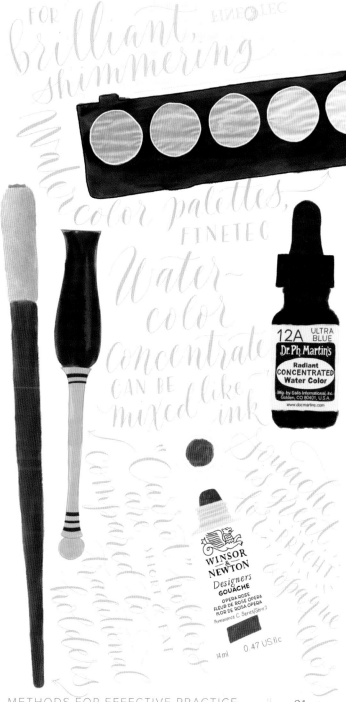

Even the most experienced calligraphers need to troubleshoot from time to time. Here are some suggestions for resolving the most common issues, from poor ink flow to shaky upstrokes to chronic hand cramps.

My letters look wobbly

- **Pen grip is too firm.** If you can't loosen up your fingers by sheer force of will, switch to a fatter penholder—such as a "carrot" holder—which requires a less tight grip. You might also try squeezing a tennis ball in your non writing hand as you work, which shifts the strain away from your writing arm. (It sounds strange but it's a really nifty trick!)

- **Forearm or shoulder are too rigid.** Practice some of the arm exercises covered on the facing page.

- **Basic strokes need to be reviewed.** Lack of practice, i.e., underdeveloped muscle memory, will lead to shaky letters. Practice the basic strokes and movement drills in the following chapter.

- **Paper is too textured.** Even the slightest uneven texture can interrupt a smooth stroke.

- **Nib is old and should be replaced.** A worn-out nib affects nearly every aspect of calligraphy, so when in doubt, try a fresh one. Occasionally nibs are duds straight out of the box, too!

- **Too much caffeine or too little sleep.** Both of these can leave you weak and shaky, so pay attention to how burning the midnight oil or drinking that third cup of coffee really affects you.

My upstrokes have no ink flow

- **Ink is too thick.** Add some gum arabic and/or water. (But some ink can't mix with water so read the label!) If the ink is thick because it's old, it may not be salvageable, especially if it had gum arabic in it, which is perishable.

- **Penholder-to-paper angle is wrong.** If your pen is touching the paper at too steep or too flat an angle, letters will be stilted and upstrokes won't flow. Move the penholder up or down in your hand until it rests against the knuckle at the base of your index finger. For some, the best angle is a bit lower than that, toward the crook of the thumb.

- **Nib-to-paper angle is wrong.** Turn the nib so the hole at the top (the "breather hole") is facing the ceiling. Some people get the best results by ro-

tating the pen in their hand so the nib is slightly turned to the left or right.

- **Writing speed is too fast.** If you write calligraphy even half as fast as you do everyday handwriting, slow down! There is no benefit in fast calligraphy if it sacrifices quality.

I'm not seeing improvement

- **This is probably not true.** You may not see the improvement because it has come slowly. Save all your practice sheets to prove this to yourself.

- **Calligraphy takes lots and lots of practice.** And once you've done that, it requires more practice still. Most professional calligraphers practice nearly every day. If you can find peace in the process, and practice rigorously and often, you are guaranteed to improve.

- **You may be aiming for quantity over quality.** Focus on a single skill, such as one flourished letter, and practice it slowly and precisely until you see a marked improvement.

My hand, back, or neck hurts

For hand cramps:
- Maintain a relaxed grip on the pen.

- Extend your fingers so that your index finger is bent at greater than a ninety-degree angle.

- Rest the outer edge of your hand (pinky side) on the desk, and the ball of your hand (thumb side) should not touch the paper.

For back and neck strain:
- Sit back in your chair, plant both feet on the floor, and lean forward slightly. Do not lean your body against the table, though, as that can inhibit arm movement. Try to catch yourself and correct your posture when you slouch over your paper.

- Keep your elbow off the edge of the table and rest just your forearm on the desk. Your arm should be able to glide across the writing surface, so do not anchor it so firmly that you feel a strain in your shoulder.

- Move the paper away from you as you write, rather than moving your arm backward with each line. A cramped writing table can lead to bad posture.

- Take regular breaks—at least a couple per hour!

Exercises for a tense arm

- Swing your writing arm to loosen up the shoulder.

- Extend your arm in front of you, palm facing the ceiling. With your other hand, gently push your fingers down toward the floor. You should feel a stretch along your forearm. Then pull down your thumb. You should feel a stretch in the ball of your hand.

- Squeeze a sand-filled stress ball, tennis ball, or other type of hand massager at various points in the day, or during work breaks.

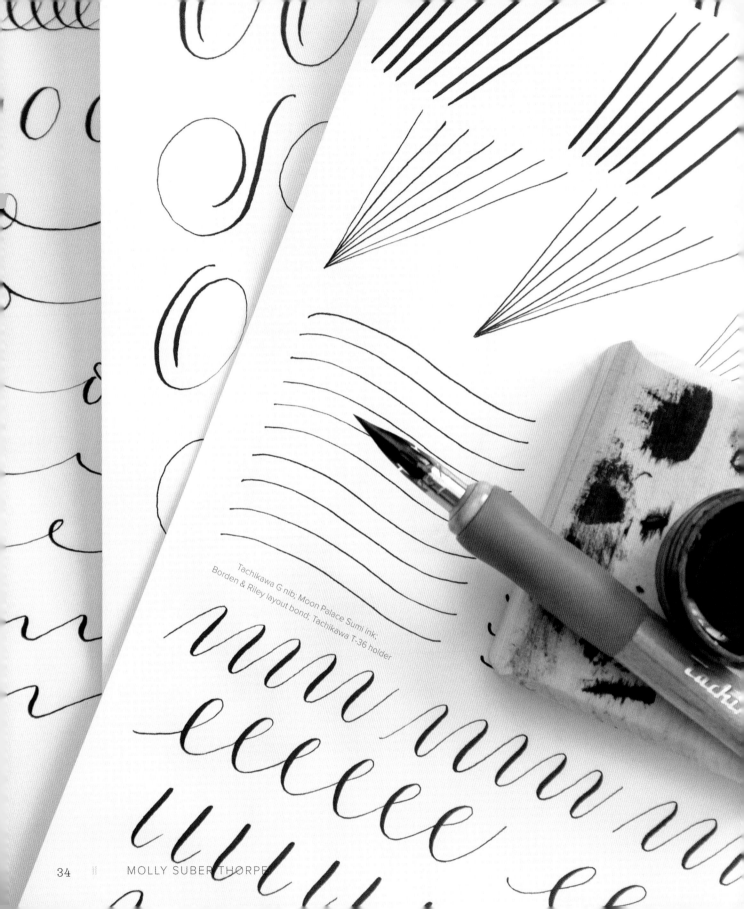

Tachikawa G nib; Moon Palace Sumi ink;
Borden & Riley layout bond; Tachikawa T-36 holder

Warm-up Exercises & Drills

A relaxed arm and shoulder are crucial for fine pen work, so doing warm-ups and stroke drills regularly is important to rid ourselves of built-up tension and relax into the flow of writing.

At once mindless and controlled, warm-ups will loosen your grip, focus your attention, and steady your breathing. The repetition of calligraphic curves and shapes also builds muscle memory.

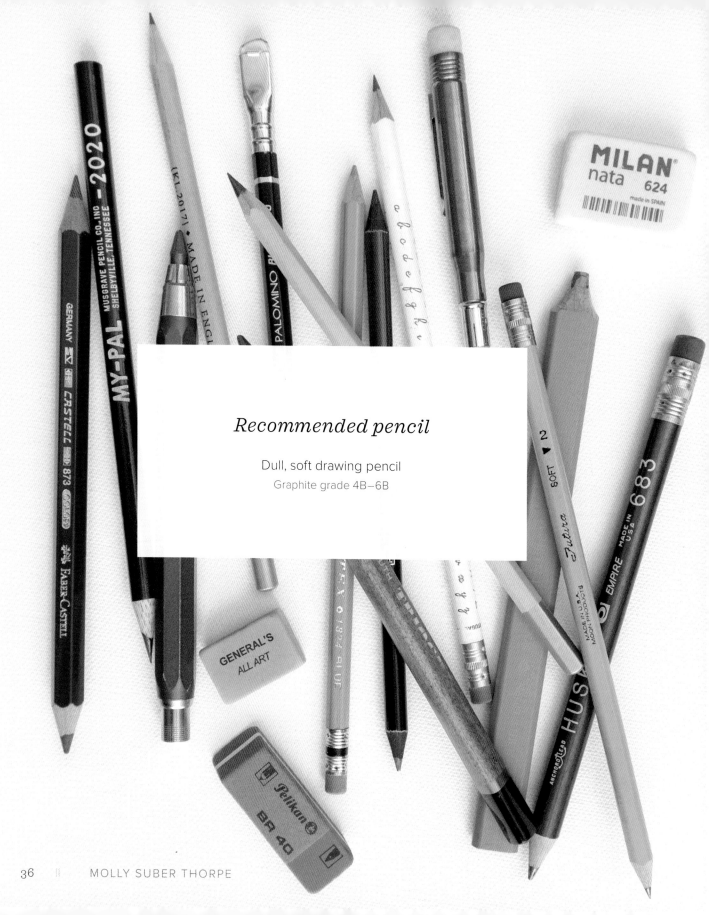

Recommended pencil

Dull, soft drawing pencil

Graphite grade 4B–6B

Pencil Warm-ups

Practicing calligraphy with a pencil is a wonderful, meditative warm-up. It allows you to isolate just your hand movement by removing the technical considerations that come with a dip pen (e.g., scratchy nibs, too much or too little pressure, and finicky ink).

Use a dull artist pencil with soft graphite so that you can practice pen pressure as part of your warm-ups, too. The pencil's dull tip will glide more easily across the page and its soft graphite will make light hairlines and thick, dark lines the more you exert pressure, emulating the stroke weight of a real pointed pen.

Drawing a large figure eight in pencil is a classic exercise and almost unbeatable in these respects. The long, back-and-forth stroke pattern is perfect for warming up the arm and training the muscles.

Carrying a pencil with you everywhere is a simple and easy way to practice letterforms and build up muscle memory on the go. But move slowly through your pencil warm-ups—it's not a speed test!

Start at the dot ⟶

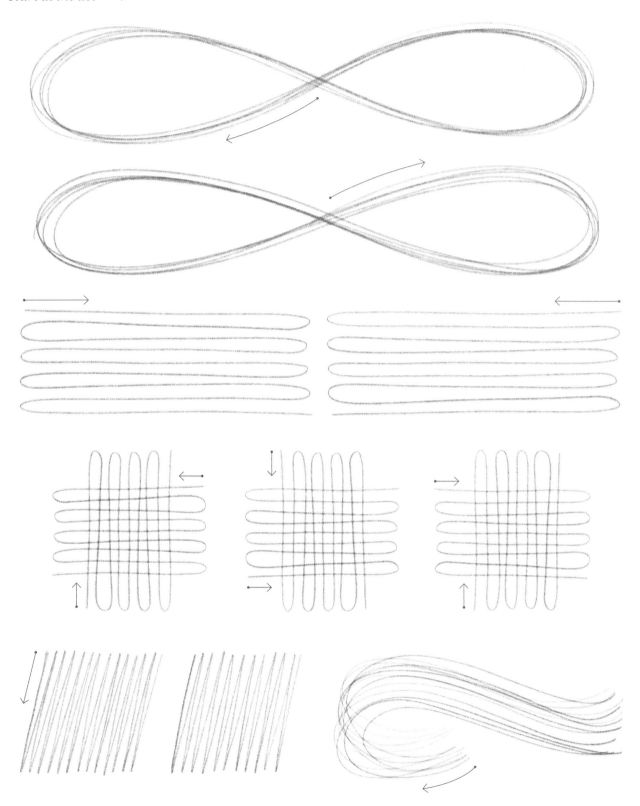

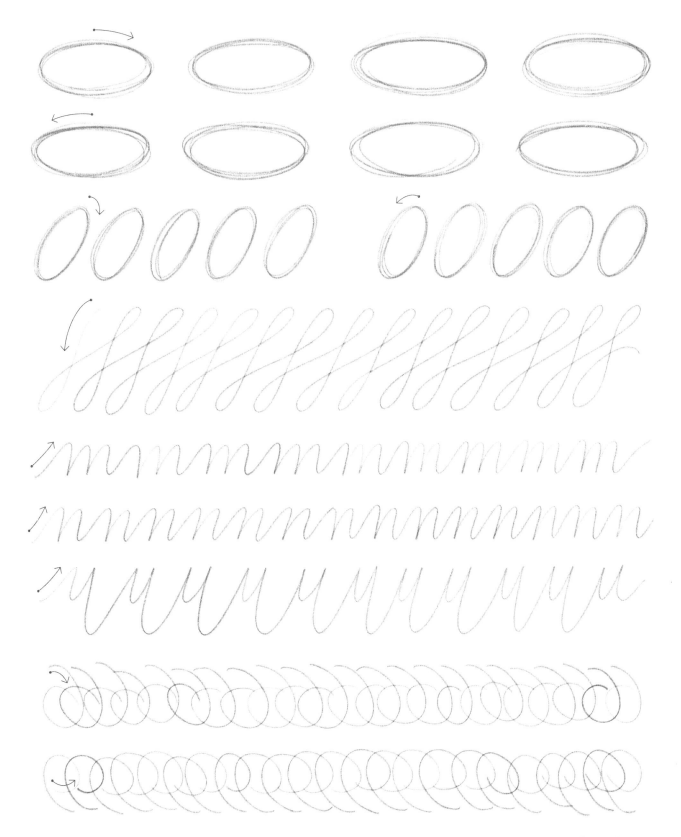

Stroke Drills

These practice drills for pointed pen progress from basic strokes (simple curves and ellipses) to challenging ones (complex curves and controlled flourishes). They are meant for building muscle memory. That is to say, repetitive stroke drill practice will train your hand and arm to draw these curves smoothly and confidently, without too much conscious thought.

Use any nib and penholder you want for these, starting with the combination you're already most comfortable with. If you switch to using a new nib or holder, come back to these to give your new tools a test-drive. Ultimately you should practice drills (and flourishes!) with a variety of nibs because they are a great way to learn the ins and outs of each one.

Even the most experienced calligrapher may find that coming back to methodical drills is useful for getting acclimated to a new nib, easing back into practice after time away, or simply as meditative training to keep the hand nimble, just as pianists practice scales.

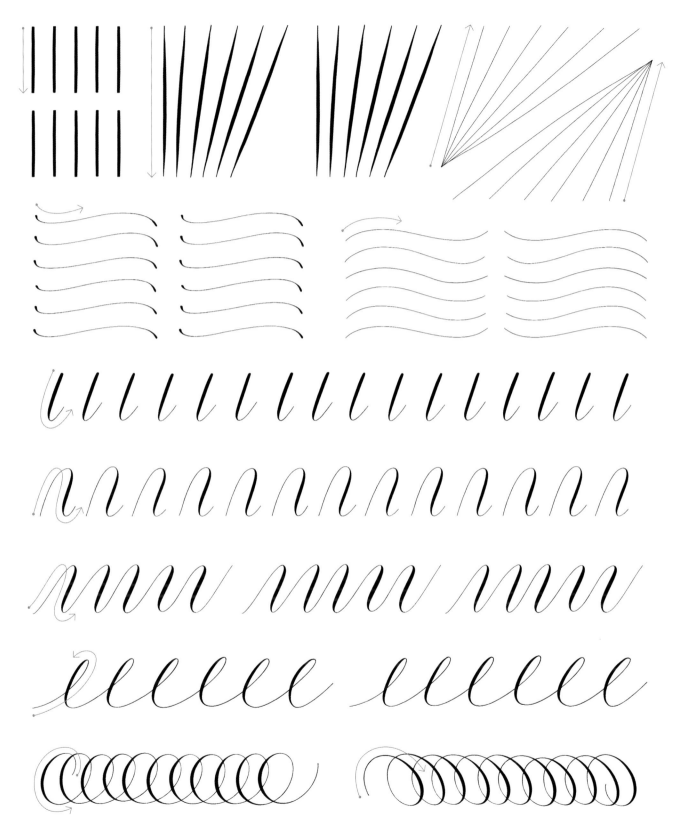

MOLLY SUBER THORPE

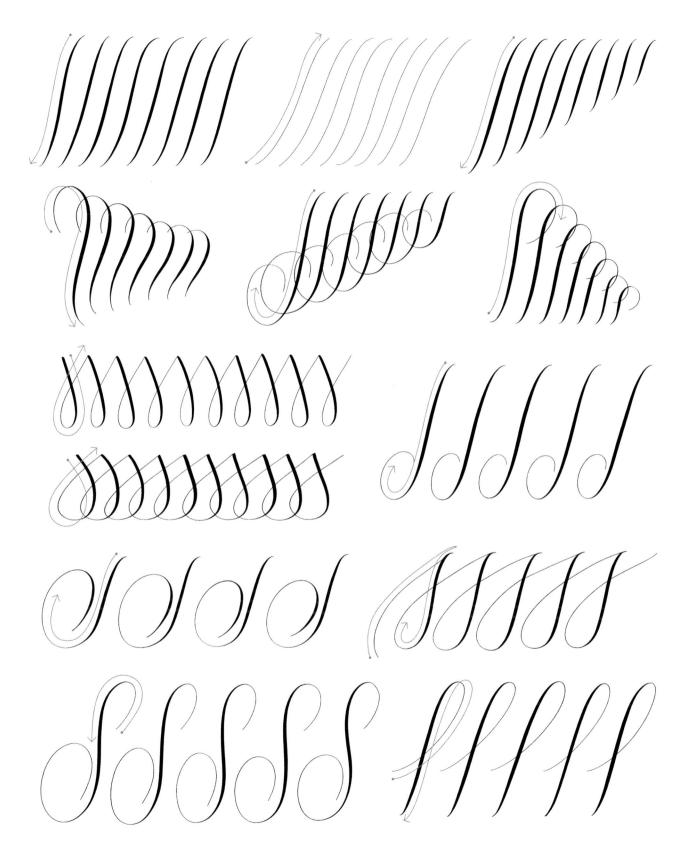

Practice Prompt

Whenever you sit down to practice, take time to do drills. Either choose a set number of minutes (maybe fifteen?) or a set number of pages to fill (maybe three?). Combine pencil and pen drills, if you wish. Draw them freehand, without tracing, if you can. Commit a set to memory so you don't have to look at exemplars. Then relax into the repetitious flow, focusing equally on your posture, grip, and breathing.

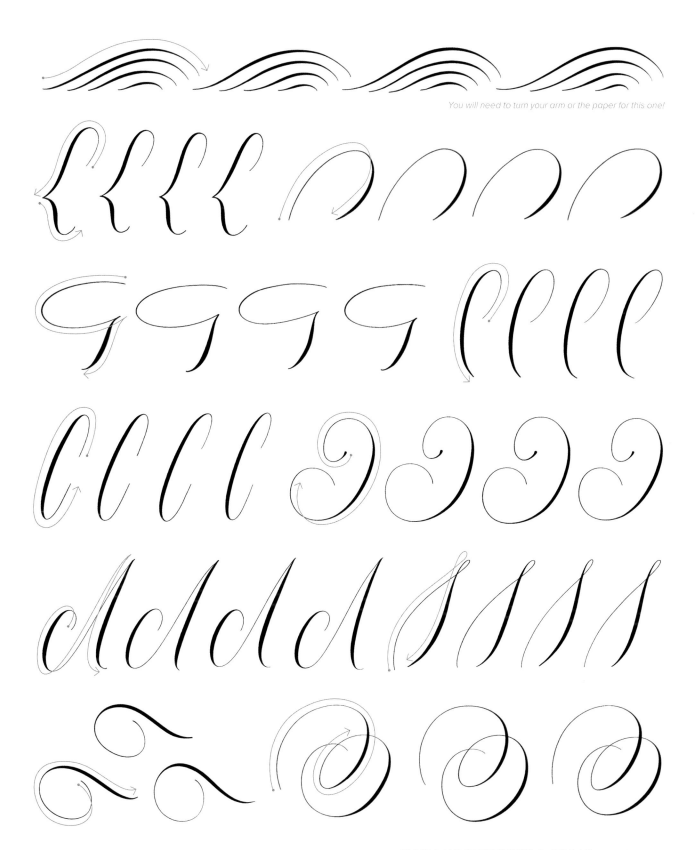

You will need to turn your arm or the paper for this one!

Aa Bb Cc

Ee Ff Gg H

Jj Kk Ll

Nn

MOLLY SUBER THORPE

Brause EF 66 nib; Tachikawa T-20 penholder (wrapped
with washi tape); Dr. Ph. Martin's Black Star Matte ink;
Canson watercolor paper; Perfetto pencil by Louise Fili

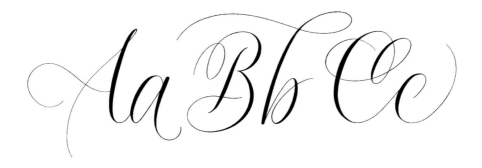

Modern Calligraphy, Letter by Letter

This chapter provides a dizzying number of letter variants, ranging from simple with minimal decoration to complex and flourished. Do not feel like you need to master these letters in order. I encourage you to flip around this chapter to look at the letters, ligatures, and words, all written in variations of the original modern basics template.

calligraphy
is a series of
repeating strokes.

calligraphy is a series of
repeating strokes.

Mastering a Modern
Basic Alphabet

The section that follows breaks down every letter of a very simple, modern style. Let's call these letterforms "modern basics." While it is a lovely script in its own right, it also makes a great starting point for creating modern variations.

If you are at an early stage in your practice where you're looking to build a strong foundation, or you just want to revisit the fundamentals, this is the place to start. Having a simple, straightforward alphabet under your belt lays the groundwork for letter variations, flourishing, and exploring your own style.

When learning *any* calligraphic style, it can be helpful to view it as a series of repeated shapes and strokes, rather than twenty-six entirely unique characters.

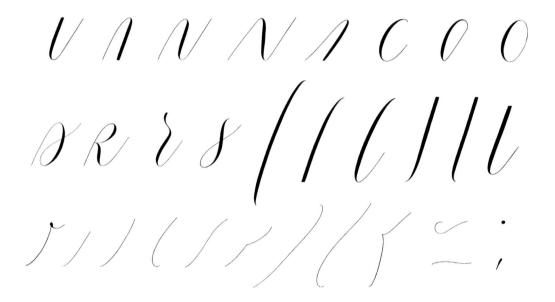

The thirty-one shapes above are the building blocks of the basic, lowercase script alphabet shown on the right. You will notice that most of the strokes are quite similar and used in more than one letter. Breaking letters down into their core strokes allows us to identify where shapes get repeated, which in turn makes for more efficient practice. No matter the lettering style you're learning, close examination will reveal that practicing one letter overlaps the practice of many other letters.

Let's take this lowercase alphabet as an example. The bowl of a is the same as the bowls of d, g, and q, and the stem of a is an undotted i. Once you learn u,

extend the stem and you make a y. Draw that stem by itself, add a tittle, and you've made a j. The long stem of d is an l, and the stems of b, h, and k are identical to one another. These are just a handful of examples that many calligraphic styles share, but different alphabets have their own unique, repeated characteristics.

I am not suggesting that because a stroke *can* be repeated it always should be. As an artist, you will add nuance to the letters, adapting and customizing alphabets to your liking. When you understand the building blocks, though, you can make these adaptations intelligently and intentionally, to give your style cohesion.

a a b b c d d

e e f f g g h h

i i j j k k l l

m m n n o o

p p q q r r s s

t t u u v v w w

x x y y z z

ARROW KEY

Throughout this book, small arrows around some letters will indicate the starting point, order, and direction of strokes. I have added arrows to every letter of the modern basic alphabet on the next page. However, for the letter variations in the pages and chapters that follow that, I have only included arrows on letters that either have different stroke patterns from the modern basic template (even though the shapes they form will differ) or on letters that appear at first glance as though they might.

The arrows' dotted ends show where you should begin a particular stroke. If an arrow does not have a dot, that means it is indicating the direction of the stroke but is not the very beginning. The arrows are also color coded, which signifies the order you should write them:

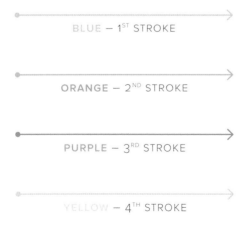

BLUE — 1ST STROKE

ORANGE — 2ND STROKE

PURPLE — 3RD STROKE

YELLOW — 4TH STROKE

un deux trois quatre
cinq six sept huit
neuf dix onze douze
treize quatorze quinze
seize dix-sept dix-huit

Brause Steno 361 nibs; Tachikawa 20 penholder in violet;
Sakura Koi watercolors; Strathmore vellum Bristol board

A MODERN BASIC ALPHABET

While this book will explore literally thousands of variations of these fifty-two script letterforms, there are a handful of basic principles that apply to their construction.

1

You can lift your pen at any point between strokes, but if you want the top curve of the letter to be a fine hairline then it is mandatory to lift before a, c, d, g, and q.

2

It is common to lift after the entry stroke of the e so you can make an upstroke curve that forms a more rounded eye (the enclosed ellipse at the top).

3

If you want the top bar of uppercase F or T to be a shaded stroke rather than a hairline (which is a matter of personal preference), then turn your arm slightly when drawing it so that you aren't exerting pressure on the pen while it's moving horizontally.

4

The only lowercase letter with both an ascender and a descender is f.

5

Traditionally, nearly straight, vertical strokes within an alphabet style are parallel to one another, no matter what their slant. The letters H, h, M, m, N, n, U, u, Y, and y are letters that contain two straight strokes (or three, in the case of m) which are customarily parallel.

6

When dotting i and j, follow an imaginary line with your eyes up the axis of the downstroke, then place the tittle (i.e., the dot) along that imaginary line.

7

There are three lowercase letters with exit strokes that come out at the waistline rather than at the baseline: o, v, and w. While this doesn't make these letters inherently more difficult, it does mean the letters that follow need to be adjusted, since their entry strokes will start high instead of low. Combinations such as or, os, vr, and wr can be especially tricky, since r and s rely heavily on their entry strokes for legibility. We will explore lots of ways to write these and other letter combinations (i.e., ligatures) in the pages that follow.

8

The top points of r and s should come slightly above the waistline so that they're optically proportional to the other lowercase letters. For some styles, the same is true for the top point of p.

9

All letters should contain at least one upstroke and one downstroke. This contrast is what gives calligraphy its beautiful flow. In the case of X and x, if you write them in a style like this, which has crossed downstrokes, then be sure the crossbars are *upstrokes*.

Ascender Baseline
Capital Descender
Exemplar Flourish
Guidesheets
Hairline Inkwell
Juncture Kerning
Ligature Majuscule

Nibs Overturn
Punctuation Quill
Roundhand Sumi
Typography
Underturn Vellum
Width x-height
Yellowing Ziller

Easy to know that
diamonds are precious.
Good to learn that
rubies have depth.
But more to see that
pebbles are miraculous.

JOSEF ALBERS

Brause EF 66 nib; Tachikawa T-20 penholder;
Moon Palace Sumi ink; Typofix millimeter paper

Modern Variations: Letters, Numbers & Symbols

The following sections are a deep dive into modern calligraphy variations, progressing from letters to ligatures to words. All the lettering principles covered in the previous chapter come into play now as we move away from the basics, tweaking and transforming letterforms until they take on new character.

I have presented the lowercase and uppercase variants alphabetically, rather than grouped into distinct, cohesive alphabets of perfectly matching styles. Practicing letters individually provides an excellent opportunity to loosen up and experiment. I believe it's important to get a taste for the sheer scope of variations that are possible in just a single letterform, and not feel inhibited by any stylistic constraints. All these letterforms can be mixed and matched, or taken as a starting point to explore your own variations. However if it's cohesive styles you're after, Chapter Five presents five distinct, modern alphabets.

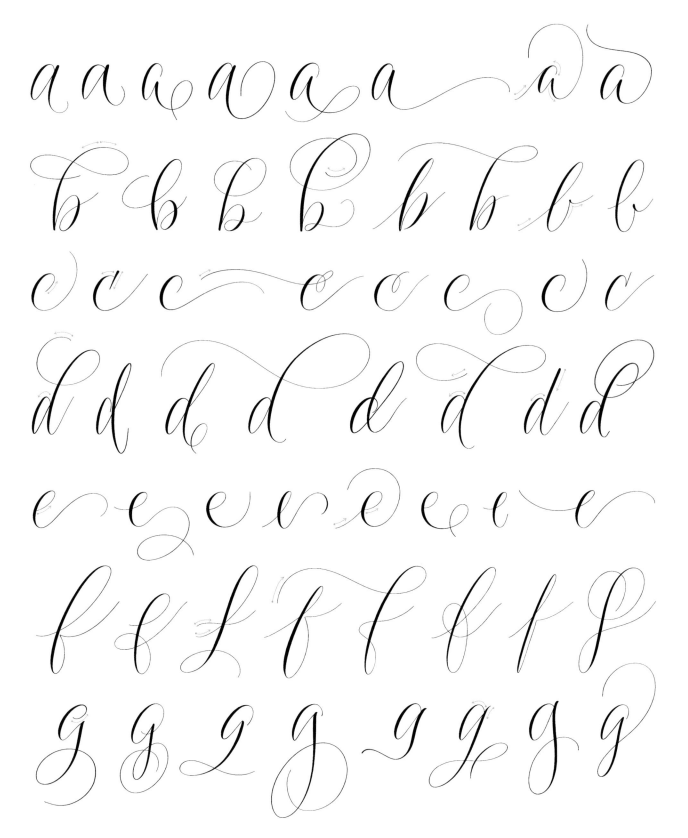

MOLLY SUBER THORPE

MOLLY SUBER THORPE

MOLLY SUBER THORPE

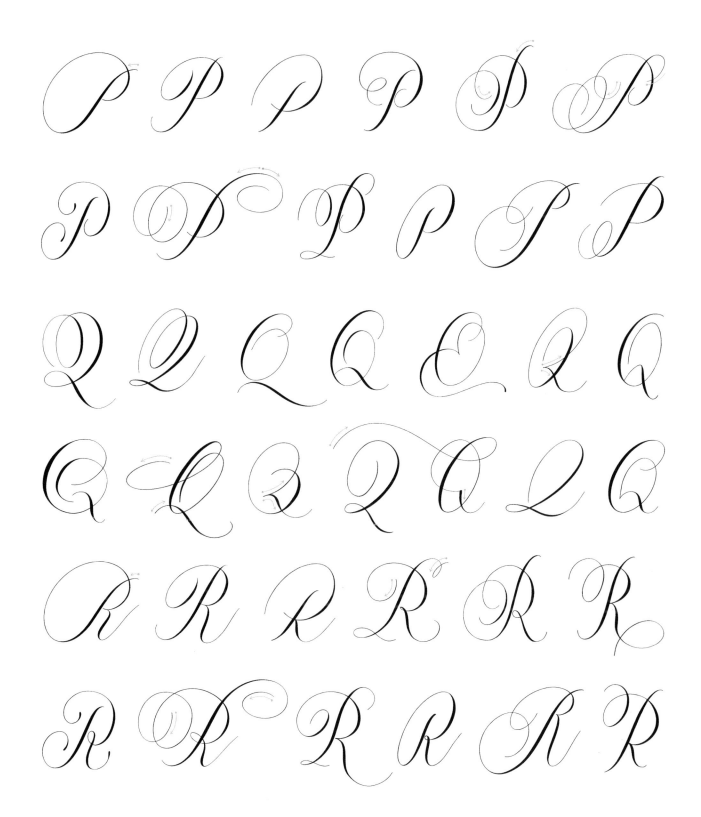

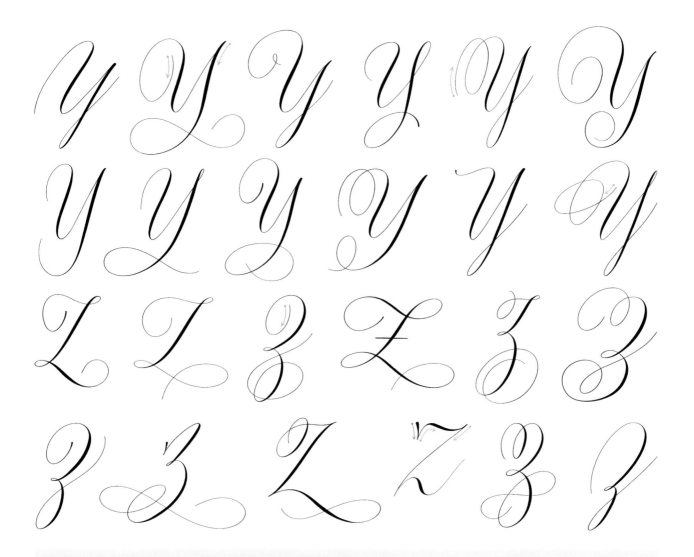

Practice Prompts

1. Choose one letter from all the variations and experiment with varying it further.

2. Write your name by selecting your first initial from the uppercase variants and then designing your own lowercase letters to complement its style.

3. Pick out a handful of letters, fill up at least one practice sheet with each of them, then try to write them again from memory tomorrow.

1 1 1 1 2 2 2 2 3 3 3 3 4 4 4

5 5 5 5 6 6 6 6 7 7 7 7 8 8 8

9 9 9 9 0 0 0 0 ¼ ½ ⅔ ¾ ⅞

№ № № № № №

? ? ? ? !! !! !? ? { { [(' ; ')] } }

@ @ @ @ © © © + + + + % % %

Modern Ligatures

Ligature: a single glyph created by the joining of two or more characters.

Arguably all calligraphed letter combinations are forms of ligatures since they are connected thoughtfully and fit together beautifully. There are, however, many letter pairs that lend themselves to especially fun connections. The pages that follow show a sampling of such pairs, all based on the modern script variants in the previous section.

ae ae ae af af af ar ar ar

bb bb bb bb bb bb bb

bl bl bl bl bl bl bl

ch ch ch ch ch ch ch

ck ck ck ck ck ck ck

dd dd dd dd dd dd dd

di di di di dl dl dl dl

ee ee ee ee ee ee ee

ff ff ff ff ff ff ff

fl fl fl fl fe fe fe

gg gg gg gg gh gh gh

gr gr gr gr gr gr gr

gy gy gy gy gy gy gy

ht ht ht ht ht ht ht

if if if if if if if

ih ing ing ing io ir is

it it it it ir it it

ki ki ki kl kl kl kl

ll ll ll ll ll ll ll

mm mm mm mm

mr. mr. mrs. mrs. mrs. ms.

nn nn nn nn nn nn

ob ob ob od od od oe

of of of of of of of

oh oh oh oh oh oh oh

oo oo oo oo oo oo oo

or or or or or or or

os os os os os os os

ph ph ph ph ph ph

pp pp pp pp pp pp

py py py py py py

qu qu qu qu qu qu

rr rr rr rr rr rr

sh sh sh sh sh sh

st st st st st st

th th th th th Th

ti ti ti ti ti ti ti

ti tt tt tt tt tt

ve ve ve ve ve ve ve

we we we we we we

wh wh wh wh wh

wr wr wr wr wr wr

Ab Ab Ab Ac Ac

Ad Ad Af Af Af

Ah Ah Ak Ak Al

Ap App Ar Ar Ar

As As As As As

At At At At Au

Ba Ba Bl Bl Bl Bl

Br Br Br Br Br By

Ch Ch Ch Ch Ch Ch

Ci Ci Ci Cl Cl Cl

Cr Cr Cr Cr Ct Ct

Dr Dr Dr Dr Dr Dr

Eb Eb Eb Ec Ec Ex

Ed Ed Ed Ef Ef Ef

Eh Eh Ei Ei Ek Ek

El El El El El Ell

Er Er Er Er Er Er

Eg Eg Es Es Et Et

Fi Fi Fi Fl Fl Fl

Gr Gr Gr Gr Gr Gr

Ha He Hi Hi Hi

Af If If If If If

Ir Ir Ir Ir Ir Ir

Is Is Is Is Cs Is

Jr. Fr. Jr. Jr. Fr. Jr. Jr.

Ki Ki Ki Ki Ki Ki

Kl Kl Kl Kl Kl

La La La Le Le Le

Ln Ln Ln Lo Ls Lo

Ly Ly Ly Ly Ly

Miss Miss Miss Miss

Mlle Mlle Mme Mme

Mr Mr Mr. Mr. Mr.

Mrs. Mrs. Mrs. Mrs.

Ms. Ms. Ms. Ms. Ms.

Mt. Mt. My My My

Na Na Ne Ne Ng

Ni Ni No No No

Of Of Of Of Of Of

Oh Oh Oh Oh Oh Oh

Or Or Or Os Os Os

Ot Ot Ot Ou Ou Ou

Ph Ph Ph Ph Ph

Pi Pi Pi Pl Pl Pl

Pr Pr Pr Ps Ps Ps

Qu Qu Qu Qu Qu

Qu Qu Qu Qu Qu

Ri Ri Ro Ro Rt.

Sa Sa Sc Sc Se Se

Sh Sh Sh Sh Sh Sh

Si Si Si Sk Sk Sk

Sl Sl Sl So So So

Sp Sp Sp Sr Sr Sr

St St St St St

Th Th Th Th Th Th

Ti Ti Ti To To To

Tr Tr Tr Tr Tr Tr

Ty Ty Ty Ty Ty Ty

Ub Ub Ub Up Up Up

Ut Ut Vo Vo Vr Vr

Wa Wa Wa We We We

Wh Wh Wh Wh Wh Wh

Wi Wi Wr Wo Wo Wo

Wr Wr Wr Wr Wr Wr

Ya Ya Ye Ye Ye Yo

Zo Zo Zo Zo Zo Zo Zo

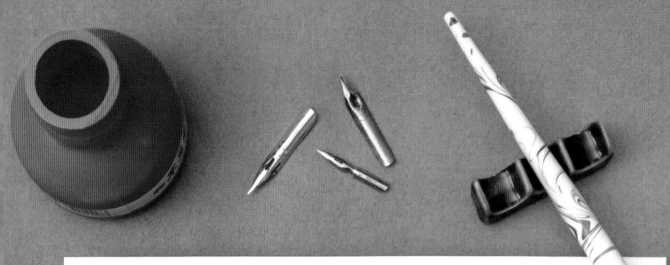

The world always seems brighter when you've just made something that was not there before.

· NEIL GAIMAN ·

Brause Steno 361 nib; e+m marbled penholder;
Yasutomo vermilion sumi ink; Warm Ceramics
pen rest; Strathmore vellum Bristol board

From Letters to Words

Now it's time to turn this letter-by-letter practice into words. In this chapter the modern calligraphy principles discussed in Chapter One are on full display: overall letter size, x-height/ascender/descender ratio, baseline shift, italic slant, stroke weight, flourish shape, and connector stroke length.

Practice Prompt

Choose a word or short phrase to write in as many different ways as you possibly can. Start by calligraphing it in your go-to style, without overthinking your stylistic choices. Then write it again, this time choosing *one* thing to change, such as the slant, x-height, adherence to baseline, descender length, etc. (Refer to pages 20–21 for more ideas about targeted changes you can make.)

Continue this process as many times as you want, making only one major change per version. Be experimental. Don't be afraid to mess up or draw something ugly! If you create a design you really like, ask yourself why so you will know how to replicate that style in the future.

Here I'm sharing my own results from this exercise: seven very different designs created by changing just one feature each time. In the pages that follow, I'll show you even more variation exercises with analyses of all the stylistic choices I made and how they affect the overall look and feel.

Forever and a day

My original design

Forever and a day

Decreased slant for a more upright style

Forever and a day

Decreased x-height

Forever and a day

Ignored the baseline

Forever and a day

Ignored the ascender lines

Forever and a day

Extended all hairlines and connector strokes

Forever and a day

Increased pressure on downstrokes

WORD EXPLORATIONS

All the designs in the three spreads that follow were drawn using only a baseline as a guide—no slant, ascender, or descender lines. I added the slant lines after the fact to illustrate the variation from one word—or letter!—to the next.

1

- An extremely long, narrow f sets the stage for this clean style, with crisp points, narrow loops, and modest entry and exit strokes.
- The light downstrokes and general adherence to a baseline and slant make this a semi-formal—yet still quite modern—style.
- Decoration is minimal and reserved for small ornaments like the cross stroke of the f and turning point atop the o.

2

- Letters are large with far-reaching yet simple flourishes.
- While mostly adhering to a uniform baseline and slant, small details convey playfulness: the flourish of the h starts at the tittle of the i, and a small curve extends from the top of the o.

3

- Large flourishes are placed only at the beginning and end of the word, with various-sized letterforms in between to create contrasts in height and style.
- Despite the free-flowing flourishes and heavy shading, the letters still adhere to a relatively uniform slant (with the exception of the backslanted h!)

4

- Very low-contrast stroke weights (light downstrokes and relatively heavy up-strokes) keep this style feeling smooth and low-key.
- Letters sit along the baseline and have tall x-heights compared to their ascenders.
- Stroke slants are highly varied, with some letters nearly vertical.

flourish 1

2 *flourish*

flourish 3

4 *flourish*

5

- Apart from the descender of the f and ascender of the h, there is very little vertical contrast between the other letters.

- The letters sit neatly on an even baseline, but the x-height and slant are only adhered to loosely.

- All curves and loops are open, airy, and playful, making for a truly whimsical style.

6

- While these letters mostly adhere to a uniform baseline and slant, they all but ignore waistline and ascender line.

- The mirroring of loops at the tops of f and h, and tops of r and s, add consistency and, in turn, elegance.

7

- Letter spacing is dramatically extended, uneven, and relaxed. The long connector strokes, combined with the heavy italic slant, convey forward movement.

- Ascenders are short relative to the x-height, and ascender loops are tiny to keep the eye focused down below, in the x-height space.

- Overall the look is minimalist and effortless, as though dashed off quickly.

8

- Letters are large and loops very round, giving a soft and airy sensation.

- Swells are bold but controlled, and certain downstrokes, such as the top loops of r and s, are left unshaded.

- The f looks almost to have slipped: its ascender is nearly at the waistline and yet it descends well below the final flourish of the h, adding whimsy and vertical contrast.

flourish 5

flourish 6

flourish 7

flourish 8

1

- Uses a 1:1:1 grid ratio, meaning ascender, descender, and x-height spaces are equal.

- Looped ascenders touch the same ascender line, while the stem of the t sits below.

- The two underturns and two overturns appear mostly uniform in width and shape.

2

- All grid lines are disregarded.

- The two words overlap but the spacing between them assures they still read as separate words.

- Downstroke weights are varied.

3

- Adheres to an even slant and x-height, but with a and o floating above the baseline and very short ascenders on the h and k, the overall sensation is playful.

- Hairline flourishes at the beginning and end bracket the phrase, making the eye travel back and forth.

4

- Adheres to an even slant and ascender height, but liberties have been taken with the baseline and letter spacing.

- Letterforms are narrow and heavily slanted, giving a sense of crisp, forward movement.

5

- All horizontal grid lines are disregarded, but an even slant is mostly maintained.

- There is an overall lack of uniformity as overturns and underturns are shaped very differently from one to the next.

- The k has a flourished ascender while the t has a straight crossbar, adding further contrast.

6

- Uniform baseline, x-height, and slant with ascenders that break free.

- A narrow, bold style that conveys discipline and uniformity. Unique hairline elements added to the tops of t and o break the monotony.

1 *thank you*

2 *thank you*

3 *thank you*

4 *thank you*

5 *thank you*

6 *thank you*

Apple Blueberry
Coconut Durian
Elderberry Fig
Grape Honeydew
Ice-cream-bean
Jackfruit Kiwi
Lychee Mandarin

Nutmeg Orange
Pomegranate Quince
Rhubarb Starfruit
Tamarillo
Ugli Vanilla
Watermelon Xigua
Yumberry Ziziphus

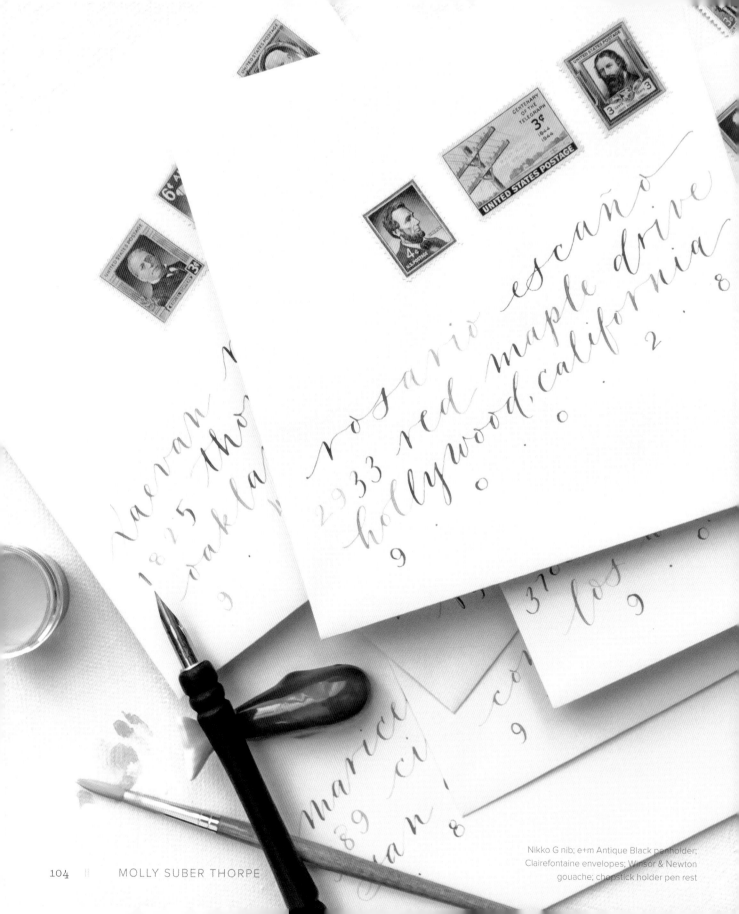

rosario escaño
2933 red maple drive
hollywood, california

Nikko G nib; e+m Antique Black penholder;
Clairefontaine envelopes; Winsor & Newton
gouache; chopstick holder pen rest

a b c d e f g h i j k l m n o p q r s t u v w x y z

Five Complete Alphabets

This chapter presents five modern alphabets in their entirety, with different letterforms than those presented in Chapter Three. These are meant to be practiced as a cohesive whole rather than letter by letter. There is still lots of room for customization and alteration, though, so consider these styles a starting point for further exploration.

Suggested nibs

A relatively stiff nib is recommended to capture this style's long, fine upstrokes and medium downstrokes.

Nikko G
Zebra G
Tachikawa T-600
Leonardt 111

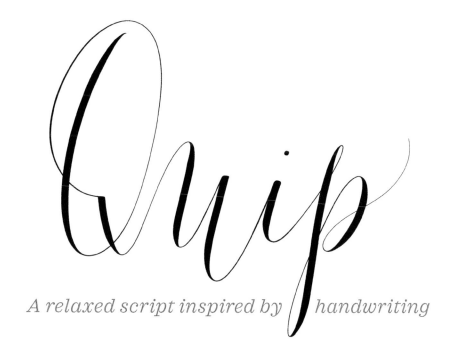

A relaxed script inspired by handwriting

Quip is a large, handwriting-inspired style characterized by narrow letterforms, irregular connector strokes, a bouncy baseline, medium downstrokes, and tight loops. While there is minimal flourishing in this style, it lends itself well to variation and customization.

Quip is a great style for casual envelope addressing. It looks especially in its element when splashed across fun envelopes in bold ink colors.

abcdefghijklmno

pqrstuvwxyz

a a a b b b c c c

d d d e e f f f

g g g h h h i i i

j j j k k k l l l

m m m m m m n n n n o o o

p p p p q q q q r r r

s s s t t t u u u

v v v v w w w w x x x

y y y y z z z

1 2 3 4 5 6 7 8 9 0

alpha bravo charlie
delta echo foxtrot golf
hotel india juliet
kilo lima mike
november oscar papa
quebec romeo sierra
tango uniform victor
whiskey yankee zulu

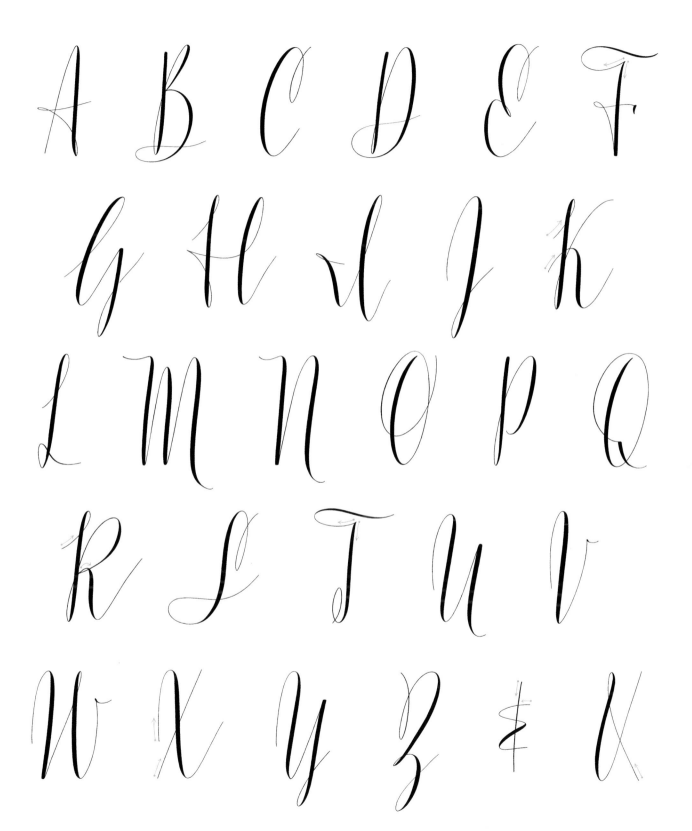

bt if ff ff fi fl ll ll

mm nn or os ot oo

qu qu sl st th tl

to tt tt tt tw wa

Ch Et Fl Fi Qu

Pr Sh St Th Wr

MOLLY SUBER THORPE

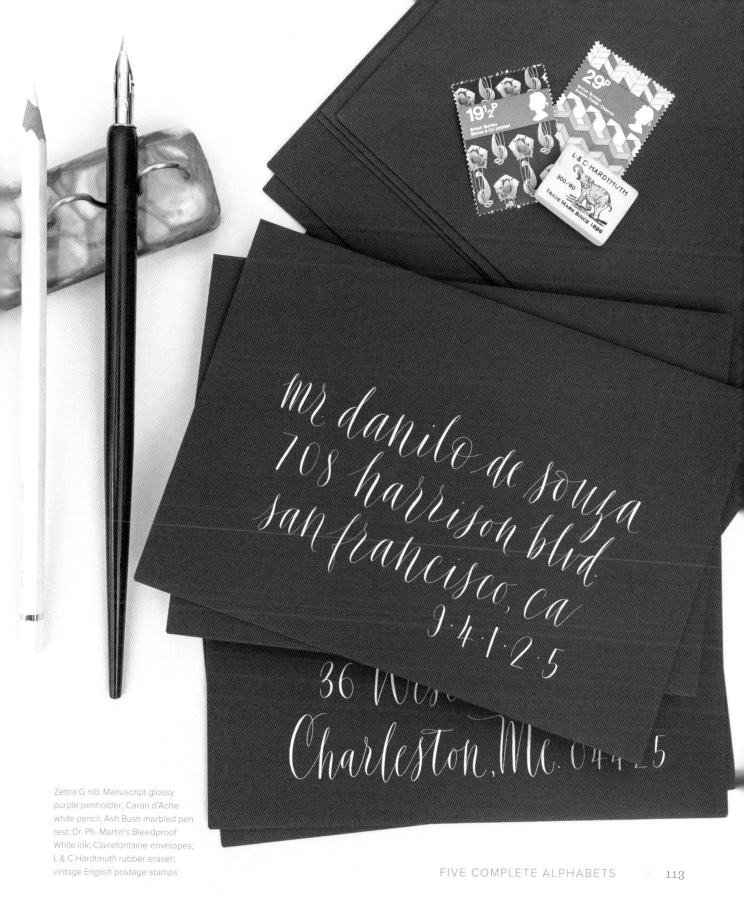

mr danilo de souza
708 harrison blvd.
san francisco, ca
9·4·1·2·5

36 West
Charleston, Mc. 044_5

Zebra G nib; Manuscript glossy
purple penholder; Caran d'Ache
white pencil; Ash Bush marbled pen
rest; Dr. Ph. Martin's Bleedproof
White ink; Clairefontaine envelopes;
L & C Hardtmuth rubber eraser;
vintage English postage stamps

Suggested nibs

The trick here is to use a smooth nib that will glide across the page for the long connector strokes. Depending on your level of experience, this could be any number of choices. A stiff nib is less likely to snag so it would be a good choice for beginners. A sharp, flexible nib will have beautiful results, too.

Zebra G
Nikko G
Brause Steno 361 ("Blue Pumpkin")
Brause Rose

Nautica

A freehand style that ebbs and flows like the tide

Nautica is so loose and free-form that learning it is more about experimentation than study. Consider this an exercise in breaking every one of the stylistic "rules" you've become used to following. This style has an irregular baseline and slant, the swells can vary from one letter to the next, and the proportions of ascender, x-height, and descender are anything but uniform. Use the exemplars as a starting point, don't use any guide sheets, and let your hand travel where it pleases.

Titanium Zebra G nib; Ziller
Wisteria ink; Ash Bush marble
carrot penholder and inkwell;
Strathmore Vellum Bristol board

a b c d e f
i j k l m n o
r s t u v w

A B C
H
N

Malmö
Orléans · Por tou...
Guingzhou · Regina
Salvador · Tangier
Uşak · Volgograd
Wellington · Xai-Xai
Yerevan · Zürich

a b c d e f g h
i j k l m n o p q
r s t u v w x y z

A B C D E F G
H I J K L M
N O P Q R S T
U V W X Y Z

Because so much of this style's elegance is in the long, uneven connector strokes, I recommend practicing whole words rather than isolated letters. Better yet, write out multiple lines of text and let them flow together like waves.

Athens · Babylon
Chicago · Delhi
Edinburg · Florence
Guadalupe · Hanoi
Ise · Jerusalem
Karachi · Latakia

Malmö · Nairobi
Orléans · Portoviejo
Quingzhou · Regina
Salvador · Tangier
Uşak · Volgograd
Wellington · Xai-Xai
Yerevan · Zürich

1 2 3 4 5 6 7 8 9 0

1 2 3 4 5 6 7 8 9 0

@ % # ! ? ? !

& & & and x

i love you

gracias

merci

thank you

MOLLY SUBER THORPE

Become wrapped up in something that you forget to be afraid.

Lady Bird Johnson

Suggested nibs

This is a large lettering style so choose a sizeable nib that holds a lot of ink and has medium flexibility so the downstrokes aren't too heavy.

Nikko G
Hunt 22
Tachikawa G

Cream Soda

A soft, everyday cursive style

The extra-large letter size, high x-height, soft curves, and medium downstroke weight make this style light and airy. The simple forms slant gently and consistently. The addition of stylistic alternates for some of the letters makes Cream Soda a happy medium between formal and fun. It's perfect for titles and signage, where oversized letters are needed.

a b c d e f

g h i j k l

m n o p q

r s t u

v w x y z

If I know
what love is,
it is because
of you.

~Hesse

Inkatable handmade
olive wood penholder;
Gillott 404 nib; Warm
Ceramics pen rest;
Moon Palace Sumi ink;
Haibara stationery

O P P Q

2 R R S

S T U V

W X Y Z

1 2 3 4 5 6 7 8 9 0

æ br ch ck

ee ex ff fr

ft gh gr it

mm ll lth

nn oy œ

oo or os ou

pr ph qu rr

sh tt th wr

Af Af Ba

Ba Br Br

Cr Ch Dr

Er Et Fi Fi

Fl Fl Ft Ft

Jr Hi He

Kl Ln Ms.

Ms. Mrs. Mrs.

Miss Miss

Mr. Mr. Of

Or Ph Pr

Pr Qu Ra

Ra Sh Sh

Ti Th Th U

Wr Wh Wh

Thank you

Welcome

You're Invited

MOLLY SUBER THORPE

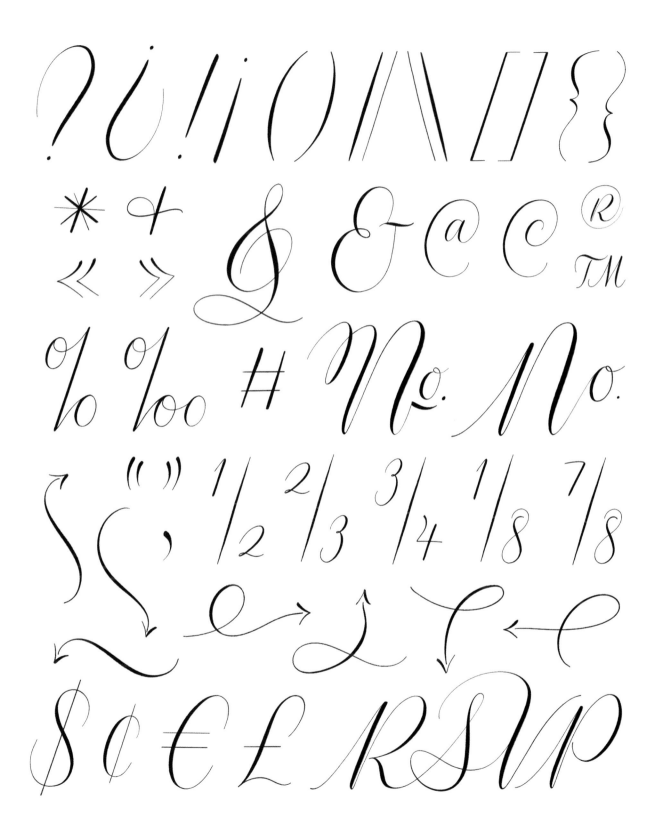

Suggested nibs

Fine hairlines are key to this style's elegance, so a sharp nib would be a good choice.

Gillott 303
Tachikawa G
Brause EF 66

Dalliance

A tall, slender, dapper hand

This script is at once elegant and quirky, characterized by a steep slant, very high contrasting letter heights, and a number of unconventional letterforms. The lowercase alphabet is mostly simple, with decorative details sprinkled throughout. The uppercase letters, however, with their narrow frames and flourishes, are more eccentric and command attention.

a b c d e f g

h i j k l m n

o p q r s t u

v w x y z

1 2 3 4 5

6 7 8 9 0

ar at bl br ch ck

dr fa ff fi fl

ht it ll mm nn

of oo or os ou pp

qu re rr sh ss st

th ti tt vr wh wr

*Skyward in air
a sudden
muffled sound,
the dalliance
of the eagles...*

WALT WHITMAN

Vintage inkwell, penholder, and nib;
Moon Palace Sumi ink; Clairefontaine paper

FIVE COMPLETE ALPHABETS

Ah At Bl Br

Ca Ch Di Du

El Et Fl Fo

Gl Gr Ha He

If In Jo Jr.

Ki Kl La Ly

Mr. Ms. Mt

Ni Ao Od Or

Pe Ph Qu Qu

Ri Rt Sh St

Th To Um Vr

Wh Wr Ya Zo

Suggested nibs

There are many monoline nibs on the market, in a variety of sizes. For these samples, I used a 0.75mm Brause Redis Ornament.

Brause Redis Ornament, 0.5–1.0mm
Brause B50 Pfannen
Speedball B5½

Blackboard Monoline

A friendly, rounded script with a backward slant

Here we have a backhand lettering style, meaning that it has a negative slant. This alone gives it a striking, offbeat quality, but it's coupled with a monoline stroke, which also makes it inviting and cheerful. The letterforms are reminiscent of schoolhouse cursive, characterized by big loops, wide letters, and uneven proportions. I've designed more than one version of nearly every letter and suggest that you mix and match them for fun.

a a b b c c d e f f

g g h i j k l m n

o o p p p q q r s s

t t u v v w w x y z

A A B B C C D D

E E F F G G S

H H H I I J I

K K L L M M

M N N N N O O

P P Q Q R R R

S S S T T U U

V V V W W W

X X Y Y Z Z

1 2 3 4 5 6 7 8 9 0

a b b c c d e f

g h i j k l m

o p p q q r s s

t u v

A B

E F

H H

K K L L M M

The quick brown
fox jumps over
the lazy dog.

Brause Redis Ornament monline 0.75mm nib;
Manuscript glossy purple penholder; Dr. Ph. Martin's
Black Star Matte ink; Strathmore Vision watercolor paper

Amber Burgundy Coral
Daffodil Emerald
Fuchsia Gold Honey
Indigo Jasmine Khaki
Lavender Marigold
Navy Ochre Periwinkle
Quicksilver Raspberry
Sepia Teal Ultramarine
Vermilion Wisteria
Xanthic Yellow Zaffre

ch ch ck ee ex ff fl ffl

fr ft gh gr gy gy it

lth mm nn oo oo

or os ow ox oy ph

ph pr qu qu rr sh

sh th th tt tt vo wr

Ar Ar As As Ba Ba

Br Br Ca Ch Ch Dr

Er Er Fi Fi Fl Fl

He He Hi Hi Jr. Ka

Ka Mr. Mr. Ms. Ms.

Mrs. Mrs. Miss Miss

Or Ph Ph Pr Qu Qu

Ra Ra Sh Sh Sh Sr.

St Th Ti Vl Vu Ya

Wh Wh Wh Wr Wr

à á â ã ä å æ ç è é ê ë

ì í î ï ð ñ ò ó ô õ œ

ö ø ß ù ú û ü ý ÿ þ

À Á Â Å Ã Ä Æ

Ç È É Ê Ë Ì Í Î Ï

Ð Ñ Ò Ó Ô Õ Ø

Ù Ú Û Ü Ý Þ ß

?¿ !¡ () \ / [] { } * ✳

℮ & ⚡ @ © ® " " ' ' « »

№ # % ‰ ½ ⅔ ¾ ⅛ ⅞

$ ¢ € £ ₫ ¥ ₸ ₹ ₡ ₩

↑ ↓ ← → ↗ ↘

hello!! ♡ ♡ ♡ #love

celebrate from: to:

thank you

Brause Steno 361 nib; Rubato handmade penholder;
Yasutomo vermilion sumi ink; Rhodia dot paper

Majuscules & Monograms

This chapter showcases three uppercase alphabets. They can be used for dramatic effect as drop caps or monograms, and combined with lowercase alphabets, too.

Suggested nibs

For these large letters with low-contrast stroke
weights, a sizable nib with medium flexibility is best.

Tachikawa G
Hunt 22B
Nikko G
Zebra G

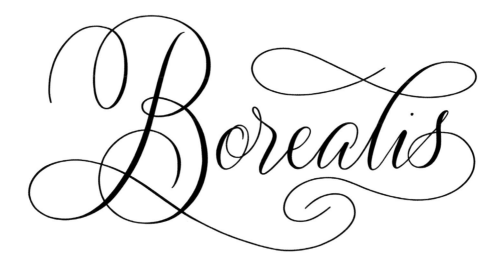

Delicate, loopy, monogram-worthy majuscules

I think of Borealis as an ideal alphabet for stand-alone initials and monograms, where a lot of fun can be had connecting or overlapping the long, wide flourishes. Borealis can certainly be combined with a lowercase alphabet, too, in which case I recommend pairing the capitals with much smaller lowercase letters that are flourished but not to the point of detracting from the capitals.

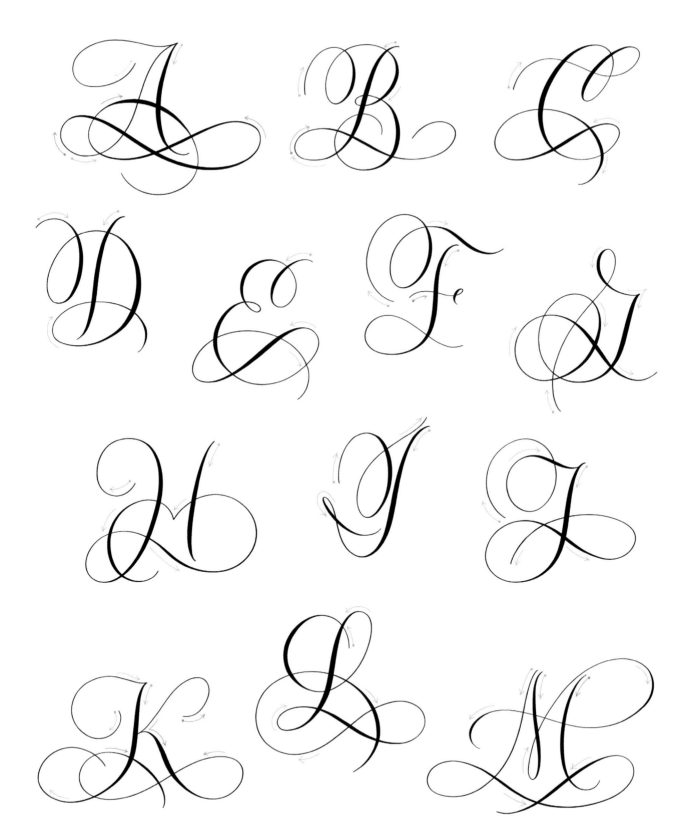

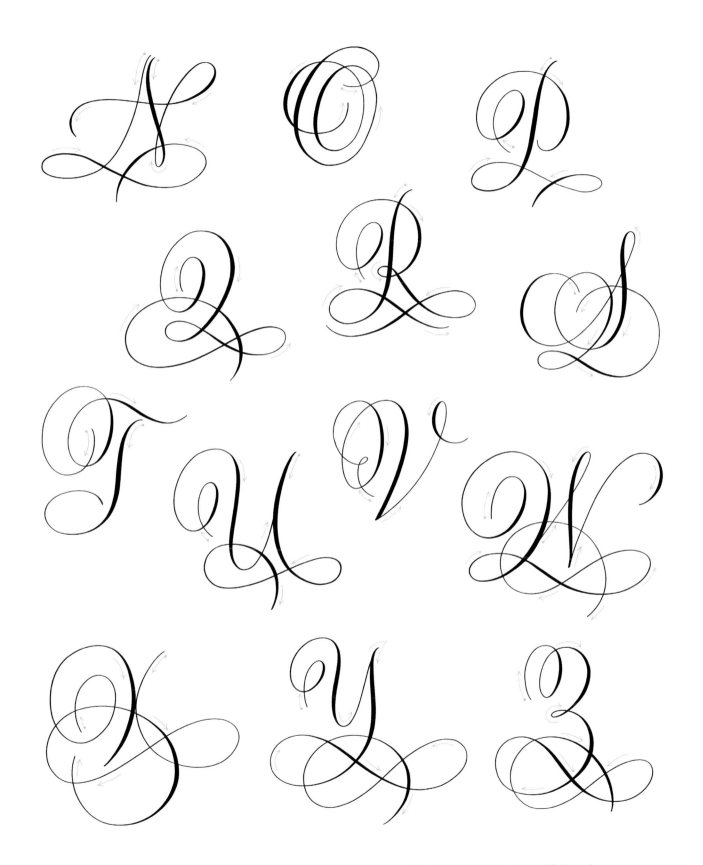

The more flourishes
a letter has, the more
you can have fun with
decoration, such as
highlight strokes and
floral embellishments in
contrasting colors.

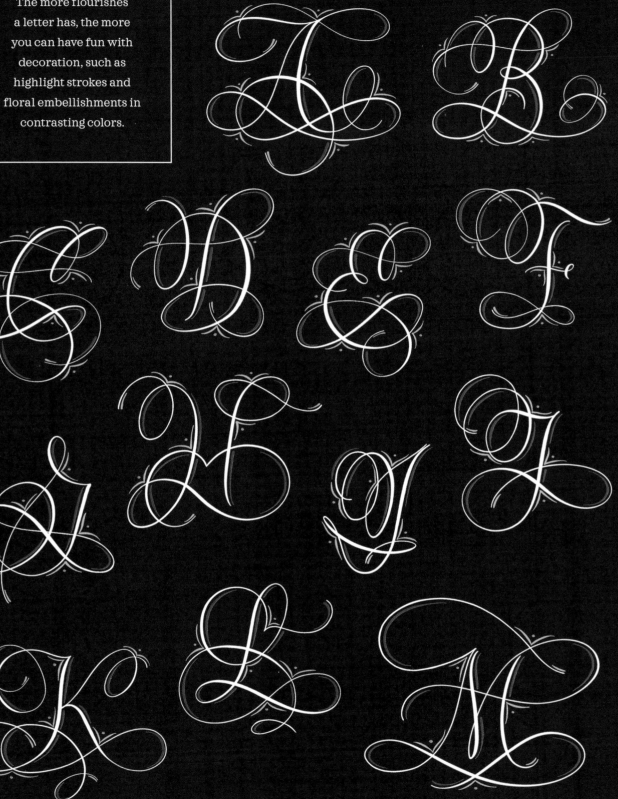

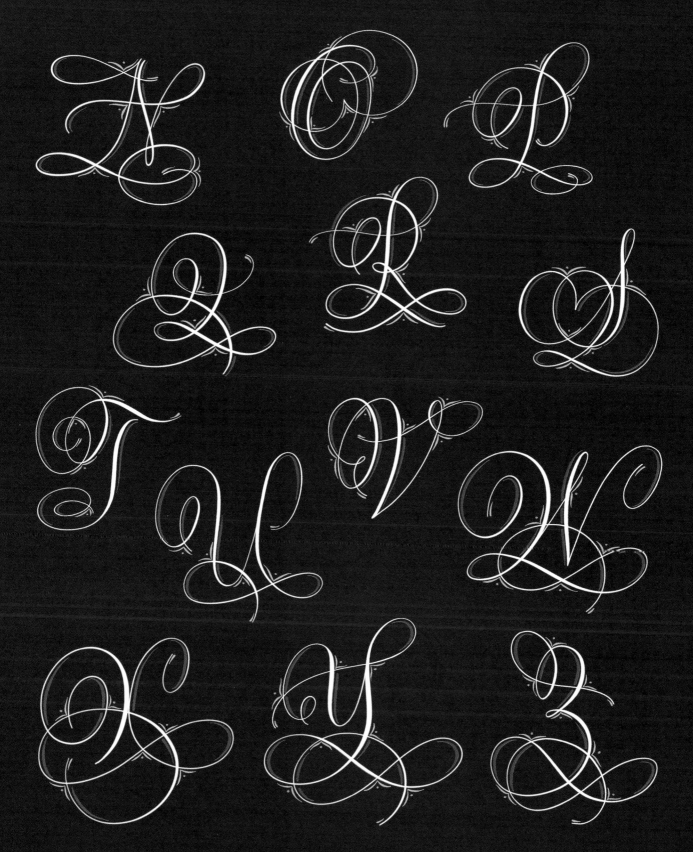

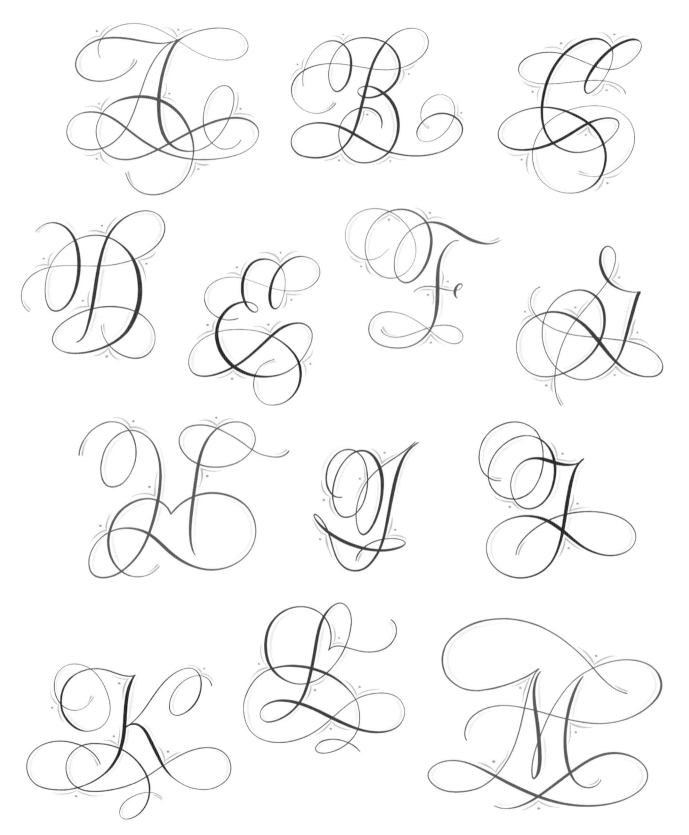

MOLLY SUBER THORPE

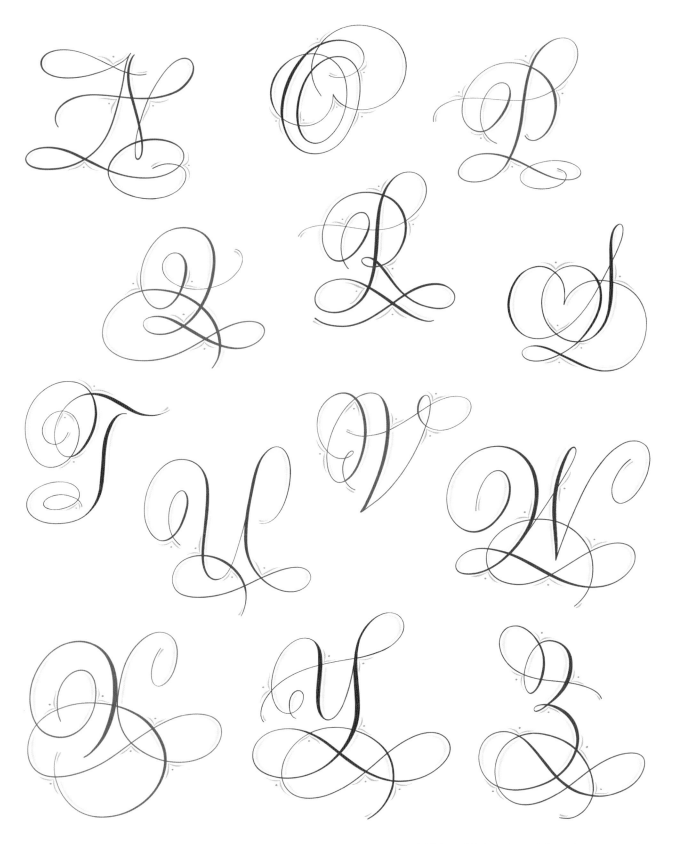

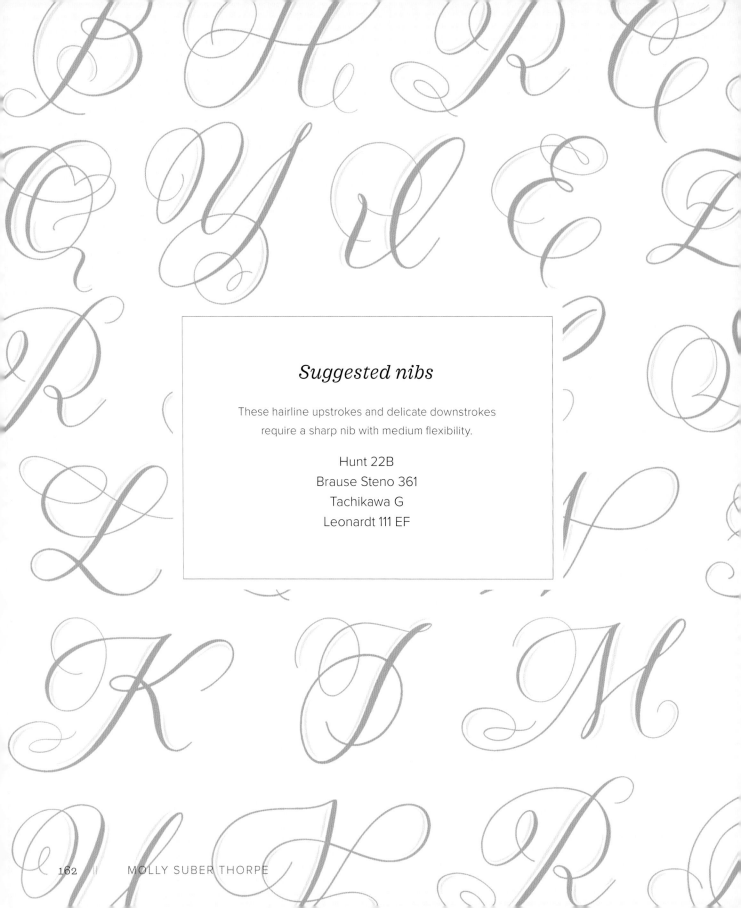

Suggested nibs

These hairline upstrokes and delicate downstrokes
require a sharp nib with medium flexibility.

Hunt 22B
Brause Steno 361
Tachikawa G
Leonardt 111 EF

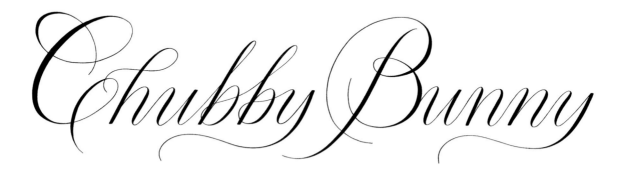

A fat & playful majuscule set

For the title of this alphabet, I paired Chubby Bunny majuscules with basic, wide minuscules. I intentionally kept a large ratio between x-height and cap height so the capitals are the star of the show. Chubby Bunny pairs well with nearly any lowercase alphabet, or as stand-alone monograms.

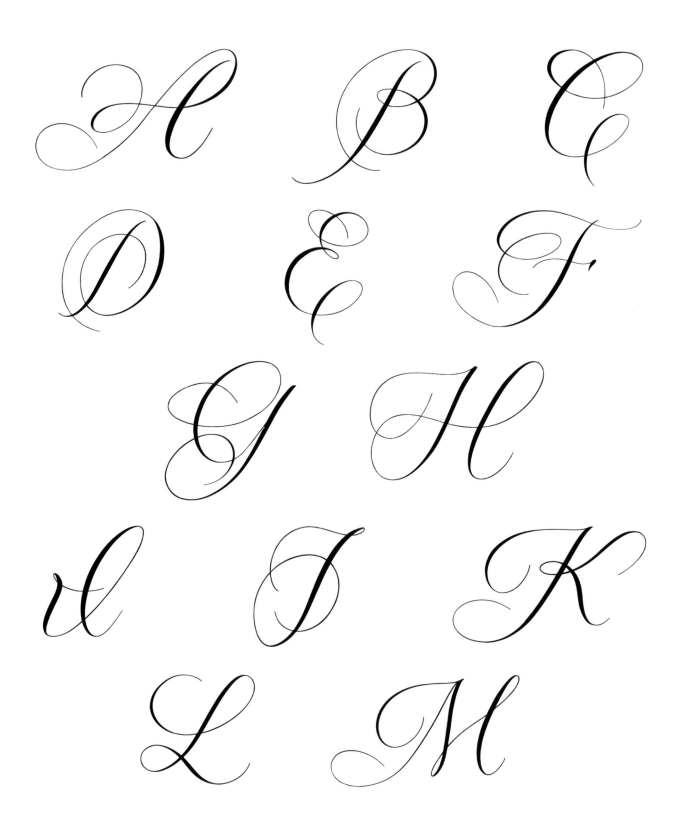

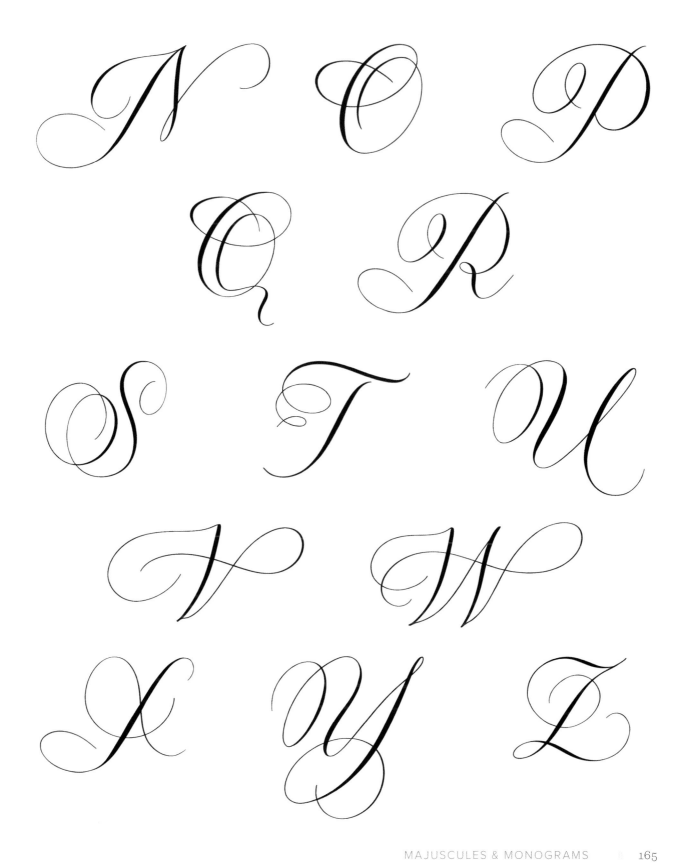

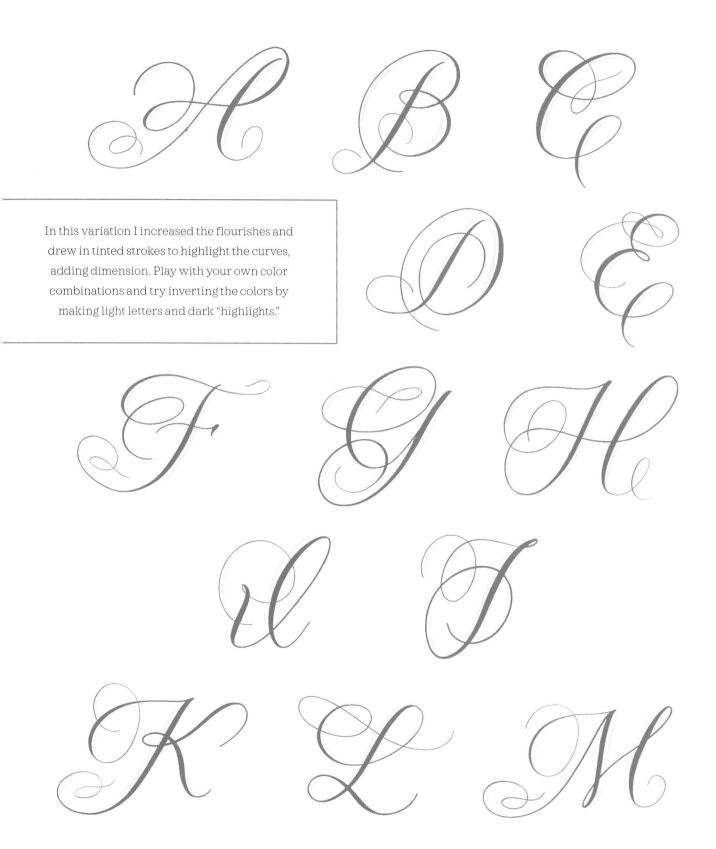

In this variation I increased the flourishes and drew in tinted strokes to highlight the curves, adding dimension. Play with your own color combinations and try inverting the colors by making light letters and dark "highlights."

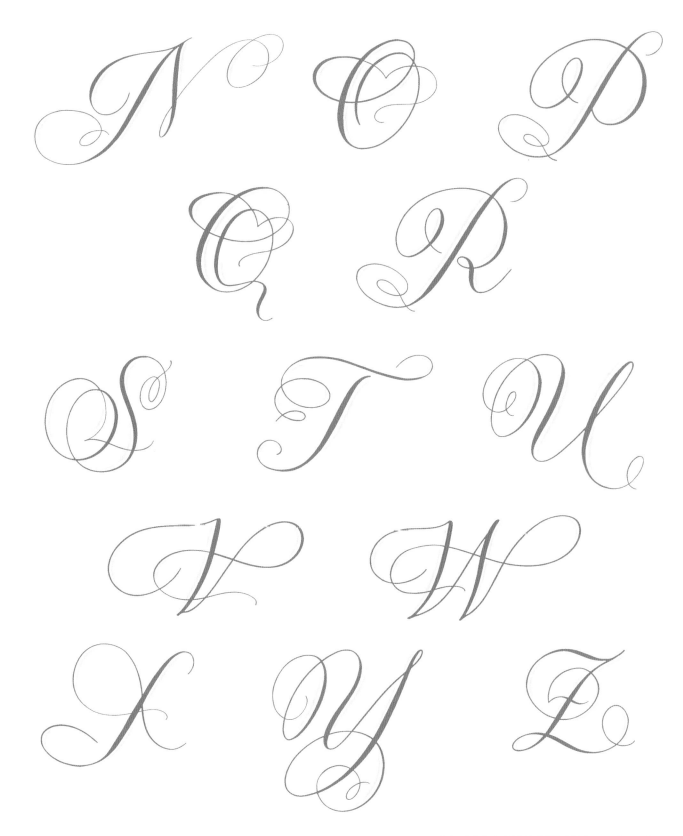

Suggested nibs

Pointed nibs:

Nikko G
Brause Steno 361 ("Blue Pumpkin")
Brause Rose

Monoline nibs:

Brause Redis Ornament, 0.5–1.0mm
Brause B50 Pfannen
Speedball B5½

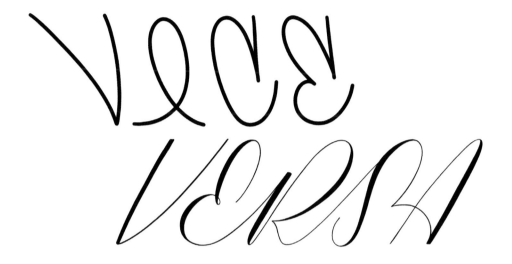

A contrarian alphabet in two slants and styles

Vice Versa is the alphabet with a rebellious streak. It can lean forward or back, and works equally well with classic pointed pens and monoline nibs. Unlike many majuscule alphabets, Vice Versa can be combined into all-caps words without overlapping flourishes or awkward spacing. It also makes a great complement to two styles from the previous chapter: Nautica and Blackboard Monoline.

A B C D E F
G H I I K
L M N O P
Q R S T U V
W X Y & Z

MOLLY SUBER THORPE

A B C D E F
G H I J K
L M N O P
Q R S T U V
W X Y Z

A B C D E F

G H I J K

L M N O P

Q R S T U V

W X Y Z

A B C D E F

G H I J K

L M N O P

Q R S T U V

W X Y & Z

Thank You

Brause Rose nib; J. Herbin Belle
Epoque penholder; Ziller Wild
Rose Pink ink; Studio Carta ribbon;
Katie Leamon pencils; HAY ruler

GENERAL'S
ALL ART

[KL.2017] ● MADE IN ENGLAND ◆ No.12//6B

[KL.2017] ● MADE IN ENGLAND ◆ No.07//2H

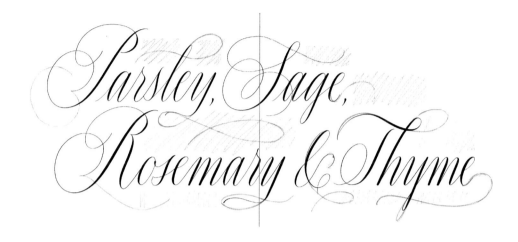

Small Layouts

This chapter will address how to combine multiple lines of calligraphy, such as on an envelope address or manuscript. Beyond the shape of each individual letter, there are new challenges to face such as how to center each line (if that's what you're after) and how to place ascenders, descenders, and flourishes so that they don't overlap or look awkward.

Lettering layouts require a great deal of practice. The best method is to dive in headfirst, make all the inevitable mistakes, critique your own work with a pencil in hand, and try again.

This is the step-by-step process I use to create flourished layouts like wedding invitations. Here I've chosen a pangram because it is a phrase that uses every letter of the alphabet—a great way to practice letterforms, too!

1

Typography is known for two-dimensional architecture and every job requires extra zeal.

2

1. I start by writing out my text in a simple, modern style. I'm not thinking too much about how the ascenders and descenders align, the shape of the flourishes, or how well centered each line is. I just want to see the words written out to get a sense of their length and overall shape.

(Instead of a pangram, consider your favorite song lyrics, a couple's names, or even a grocery list!)

2. Next I turn my paper upside down so that I can evaluate the negative space (a.k.a. white space) and line heights. I like this upside-down trick because when the words themselves aren't distracting, I can focus on the layout shape itself. I draw a center line, fill in empty areas that stand out to me, and circle places where two or more strokes either collide or look like they're about to (which I call points of tension).

3

Typography is known for two-dimensional architecture and every job requires extra zeal.

4

Typography is known for two-dimensional architecture and every job requires extra zeal.

3. Now I use a pencil to sketch my edits, adding bigger flourishes to fill the negative space and arrows to indicate lines that need to shift left or right, toward the center. (Tip: try enlarging all your loops and flourishes dramatically. You may be underestimating just how large these loops can get and still be in proportion!)

4. With my edits in place, I'll either redo the design freehand or use a lightbox to trace it. Sometimes it still takes a couple attempts to get the layout looking just how I want it.

5. To highlight all the changes I made, I've overlaid the final design (blue) on the original (pink).

5

Typography is known for two-dimensional architecture and every job requires extra zeal.

Parsley, Sage, Rosemary & Thyme

Continuing to practice small layouts like this will pay off. Over time your ability to foresee awkward spacing and overlapping loops will improve to the point that you can make lovely layouts freehand. But even professional calligraphers make edits like these when designing large or important layouts, like invitations and manuscripts.

Parsley, Sage,
Rosemary & Thyme

Parsley, Sage,
Rosemary & Thyme

Parsley, Sage,
Rosemary & Thyme

Curving or slanting your baseline is always a fun challenge. Designs like these make great holiday cards, rubber stamps, and repeating patterns, such as for wrapping paper. Since they often need to be polished for reproduction, I usually start with a pencil sketch to refine it to my liking before inking it.

The corresponding guide sheets can be found in Appendix I.

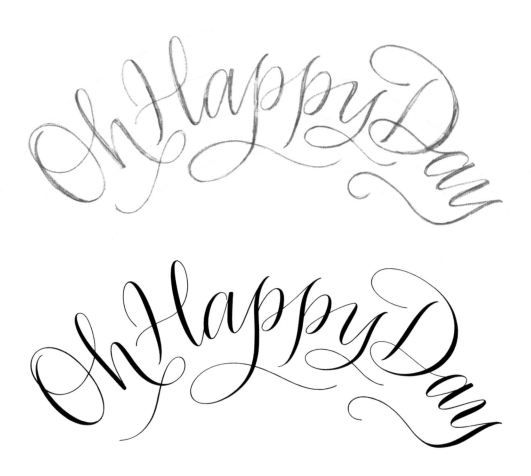

carpe diem

SEIZE THE DAY

carpe diem

SEIZE THE DAY

carpe diem

SEIZE THE DAY

carpe diem

SEIZE THE DAY

carpe diem

SEIZE THE DAY

carpe diem

SEIZE THE DAY

carpe diem

SEIZE THE DAY

carpe diem

SEIZE THE DAY

Thought is free. ~Shakespeare

Thought is free. ~Shakespeare

Tell the truth, but tell it slant.

EMILY DICKINSON

It's a poor sort of memory that works only backwards.

LEWIS CARROLL

from the
library of
Roxanna Xu

if found, please email
hi@roxannaxu.com

Te amo. Je t'aime. Ich liebe. I love you.

ms. quinn harlow
& ms. alani frye
17 bouverie road
weston - on - trent
DE72 4EJ

palnaik
omenade
rd-on-thames, oxford
OX4 4XY

mr. & mrs.
nelson haynes
red lion hill
barnet, greater london
N2 8BN

blaise bla
oxhey, watford
hertfordshire
WD19 4HB

Brause EF 66 nib; Yoke Pen Co. The Deuce 2-in-1 penholder; Dr. Ph. Martin's Bleedproof White ink; vintage gold envelopes; vintage British postage stamps

Envelope Addressing

Envelope addressing is many calligraphers' bread and butter. Just like individual letterforms, envelope addresses allow for infinite variations and stylistic choices. They provide a chance to show off your technical skill, individual lettering style, attention to detail, and eye for unique layouts. Thus, striking, memorable envelope address designs set a calligrapher apart. It really pays off to experiment a lot on your own, so incorporate addresses into your daily practice, and send friends and family lots of snail mail. And don't forget how much fun there is to be had with postage, air mail stamps, return addresses, and envelope seals!

If your style relies on adhering to grid lines, then I recommend creating an archive of layout templates for yourself to have on hand when orders come in. Make guide sheets specifically for common envelope sizes, invest in a light pad so you can easily see the lines through light-colored envelopes, and/or invest in a laser liner (a writing surface with an affixed laser that projects straight lines) which is especially helpful for opaque papers. (See Appendix III for shopping resources.)

The pages that follow show samples of address designs in various layouts and styles, including four of the alphabets from Chapter Five. You will also find all-caps styles to combine with script for contrasting effect. You can use a pointed pen for any of these, but you can also use a rollerball pen, such as a Gelly Roll, or a fine felt tip marker, such as a Sakura Micron.

If you have questions about pricing your envelope addressing work, I offer straightforward advice on this and many more topics in my second book, *The Calligrapher's Business Handbook*.

Mr. Sharif Rushdi

4781 Quilly Lane

Columbus, Ohio

4 · 3 · 2 · 1 · 5

Cream Soda

Yamen & Jazzra Knox

7225 Poe Lane

Kansas City

Missouri 64102

Quip

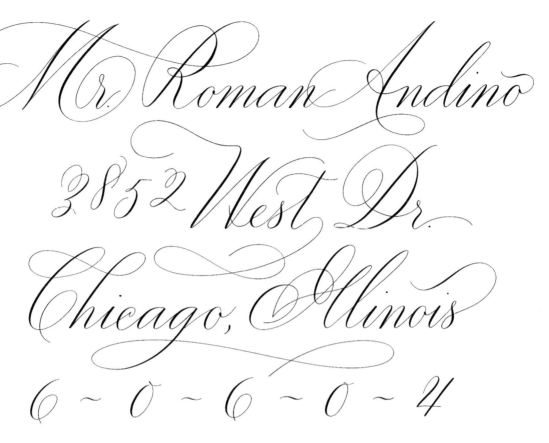

Mr. Roman Andino
3852 West Dr.
Chicago, Illinois
6 ~ 0 ~ 6 ~ 0 ~ 4

Dalliance

nichola patrickson
& turner grooten
1146 st. jean baptist
st. magloire · québec
g0r 3m0 canada

Nautica

ALL-CAPS STYLES

Combining script styles with contrasting print lettering can be very striking. Here are three samples of all-caps alphabets and their combinations with script, but the possibilities are endless!

The guide numbers below reference guide sheets in Appendix I.

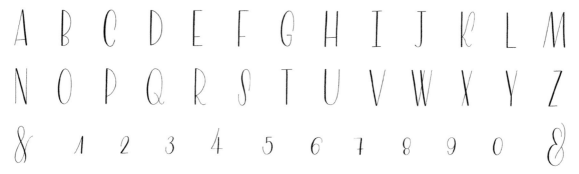

Upright, slim style with small, contrasting numbers • Perfect for a very stiff nib • Guide No. 6

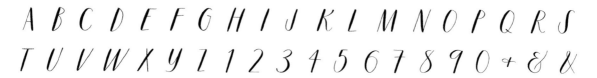

Bold style at a 72-degree slant • Great with a small, flexible nib • Guide No. 1

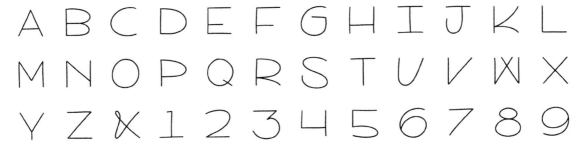

Monoline style where each character fills a square • Ideal for a rollerball pen • Guide No. 10

Mme. Claudie Lémery
3466 HOFFMAN AVE.
BROOKLYN · NY · 11206

Miss Sofia Zografos
157 MASSACHUSETTS AVE.
WASHINGTON, D.C.
2 0 0 3 6

Mr. & Mrs. Carlo Labrador
3171 ASHCROFT COURT
LA MESA, CALIFORNIA 92041

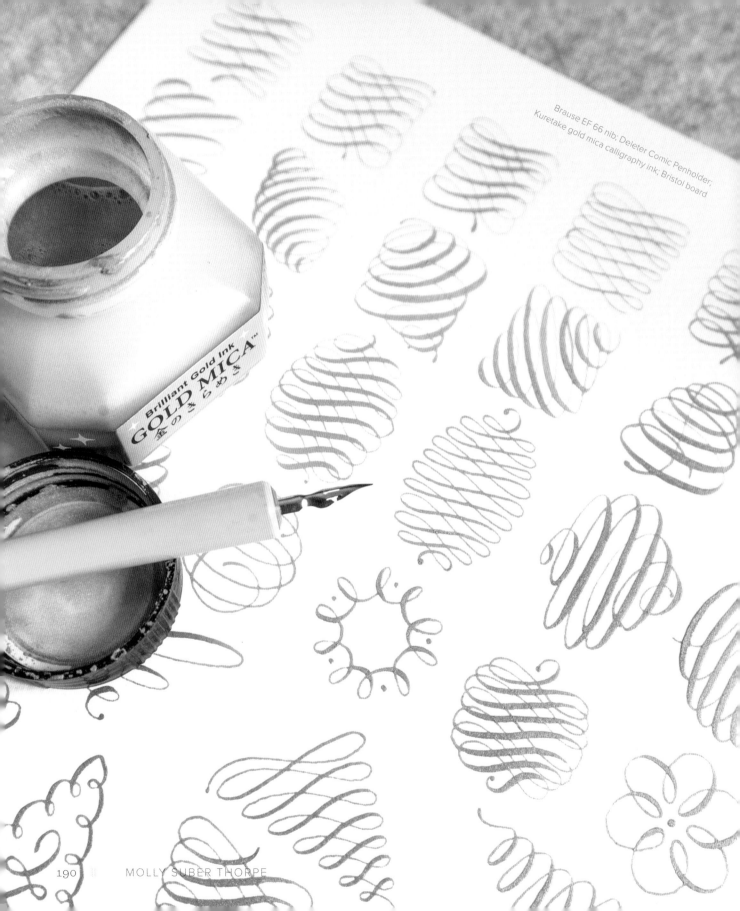

Brause EF 66 nib; Deleter Comic Penholder;
Kuretake gold mica calligraphy ink; Bristol board

MOLLY SUBER THORPE

Flourishes & Borders

In this chapter you will find more than one hundred decorative and illustrative flourishes of varying difficulty, including modern variations on historic botanical flourishes. If you're new to flourishing, start with the controlled shape drills on the next page. Beyond that are delicate swirls and swashes, decorative corner ornaments and borders, and finally, wreaths and laurels.

Flourishing Is a Test of Calligraphic Fluency

Flourishing is the perfect way to hone your technical skills. You can't flourish well if you have pressure on your upstrokes, a strained grip, a stiff arm, poor ink flow, or bad paper. Thus, flourishes are one of the ultimate tests of calligraphic fluency, beautifully combining advanced technical skill with an artist's eye.

These shape drills are a great place to start because they give you boundaries, which are very helpful when your hand doesn't yet know how far to travel! Experiment with pressure and arm movement, which is just as important as hand movement for these long strokes. A blank template is provided in Appendix I but you can also draw any shapes you like.

Ultimately you should practice flourishing with a large variety of nibs. If you're just getting started, you might prefer a stiff one to avoid the pen snags, like a G nib. To get the finest of hairlines, though, you will need a sharp nib, and those tend to be more flexible. Heavy or extremely long penholders can be unwieldy for flourishes, which need a quick, light touch, so you may also want to test out a small, lightweight holder.

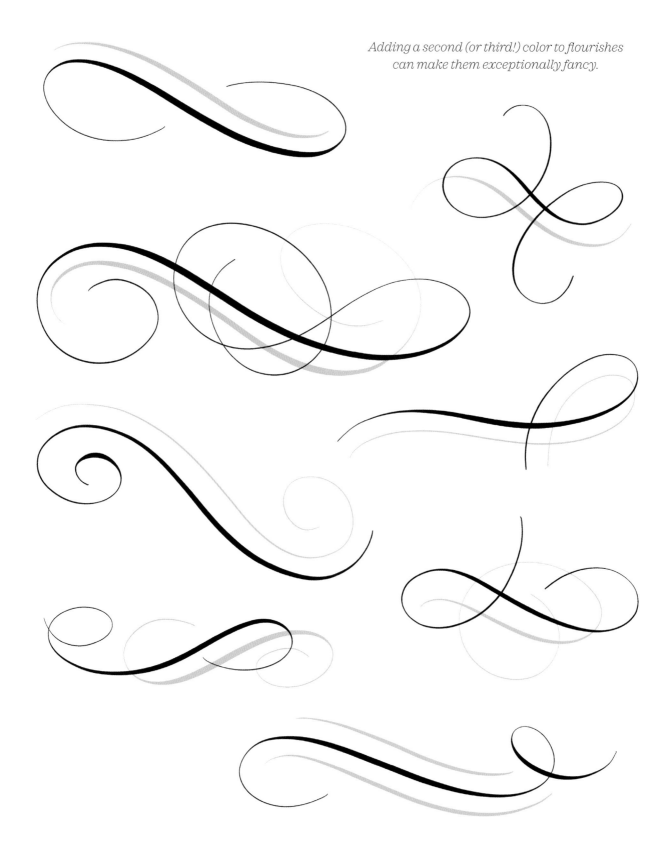

Adding a second (or third!) color to flourishes can make them exceptionally fancy.

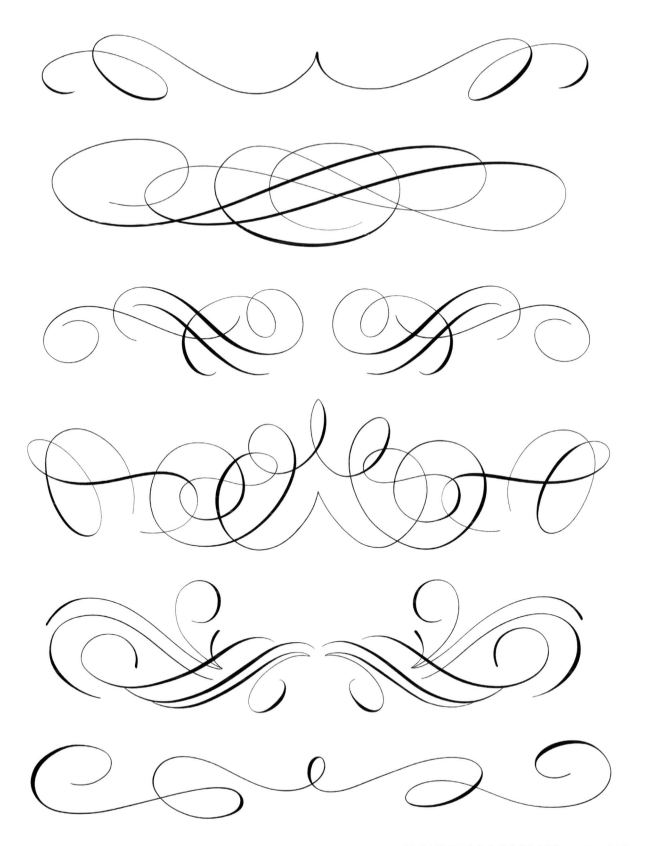

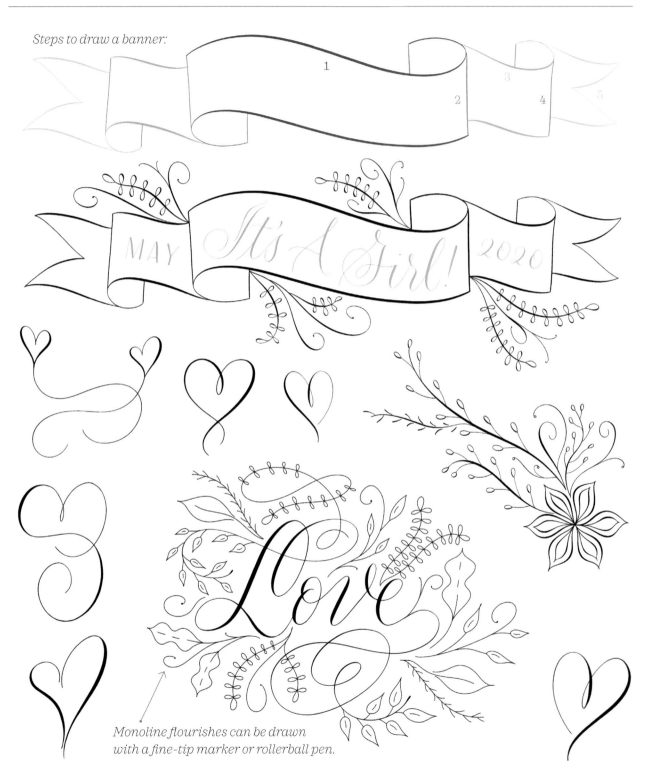

Steps to draw a banner:

Monoline flourishes can be drawn with a fine-tip marker or rollerball pen.

wreaths and laurels

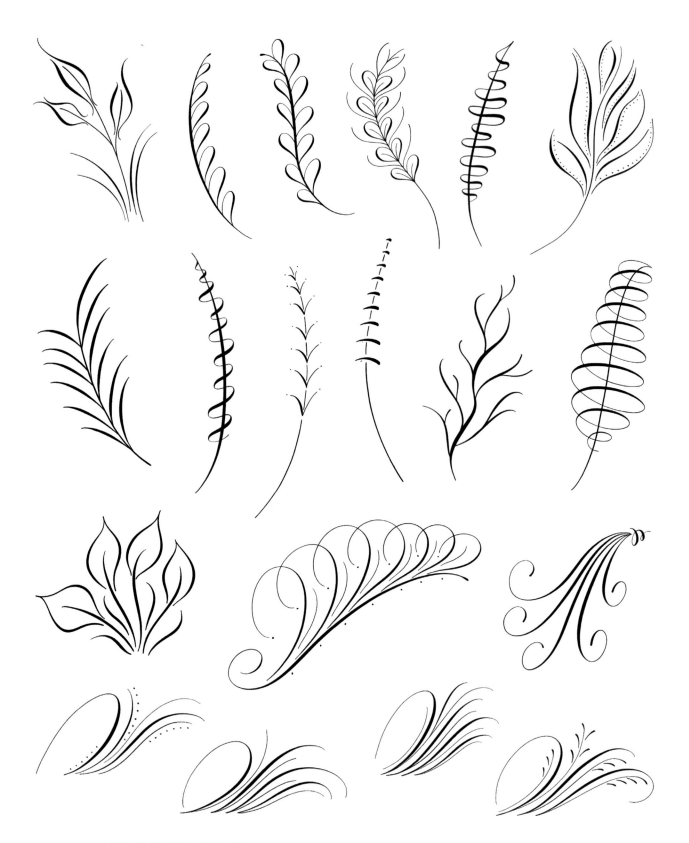

MOLLY SUBER THORPE

Appendices

Grids & Guides • Glossary • Additional Resources

Sakura Koi watercolor sketch set;
Strathmore Vision watercolor paper

Huion Wireless, USB-Powered, Adjustable Brightness Lightpad; Westcott 12x2-inch grid ruler; AlumiCutter 24-inch cork-baked ruler; vintage pica ruler; Paper & Ink Arts Copperplate Practice Paper; Nicole self-healing cutting mat; Edding 140S super-fine permanent pen; Viarco pencil; MT washi tape

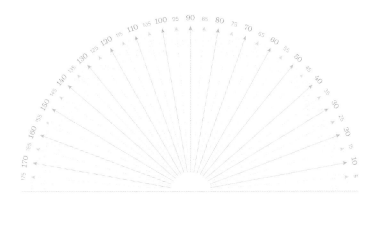

Grids & Guides

Different calligraphic styles correlate to different line heights and italic slants. This appendix includes many different guideline sheets and grids that you can use with tracing paper or photocopy onto practice paper for your own personal use.

The ratios given are C:A:x:D (i.e., the ratio of cap height to ascender height to x-height to descender length). In the instances where the cap height is no different from the ascender height, cap height has been left off.

Guide № 1

Ratio: 1:1:1 · Slant: 72° · For equal-proportioned, medium-sized letters at a moderate slant

A

x

D

A

x

D

A

x

D

A

x

D

A

x

D

A

x

D

A

x

D

A

x

D

A

x

D

Λ

x

D

A

x

D

Guide № 3

Ratio: 2:1:2 · Slant: 65° · For very small lowercase letters and space for dramatic flourishes

A

x

D

A

x

D

A

x

D

A

x

D

A

x

D

A

x

D

C

A

x

D

C

A

x

D

C

A

x

D

C

A

x

D

C

A

x

D

C

A

x

D

C

A

x

D

C

A

x

D

Guide № 5

Ratio: 1:2:1:1.5 · Slant: 48° · For tall letters at an extreme slant

C

A

x

D

C

A

x

D

C

A

x

D

C

A

x

D

C

A

x

D

C

A

x

D

MOLLY SUBER THORPE

C

A

x

D

C

A

x

D

C

A

x

D

C

A

x

D

C

A

x

D

C

A

x

D

C
A
x
D
C
A
x
D
C
A
x
D
C
A
x
D
C
A
x
D
C
A
x
D
C
A
x
D
C
A
x
D

A

x

D

A

x

D

A

x

D

A

x

D

A

x

D

A

x

D

A

x

D

A

x

D

A

x

D

A

x

D

A

x

D

A

x

D

A

x

D

Guide № 11 Slanted baselines · For sloped and skewed calligraphy

A

x

D

A

x

D

A

x

D

A

x

D

Guide № 13 Flourish drill frames

MOLLY SUBER THORPE

RULERS & PROTRACTOR

These tools are here for you to create your own guide sheets or measure the height and slant of lettering you've already made. Overlay a sheet of tracing paper to draw baselines and slants, and have fun experimenting with unusual combinations of the two!

Common range for backhand styles

Common range for modern styles

Copperplate: 55°
Spencerian: 52°

INCHES

0

1

2

3

4

5

6

7

8

9

Turn page for centimeters ⟶

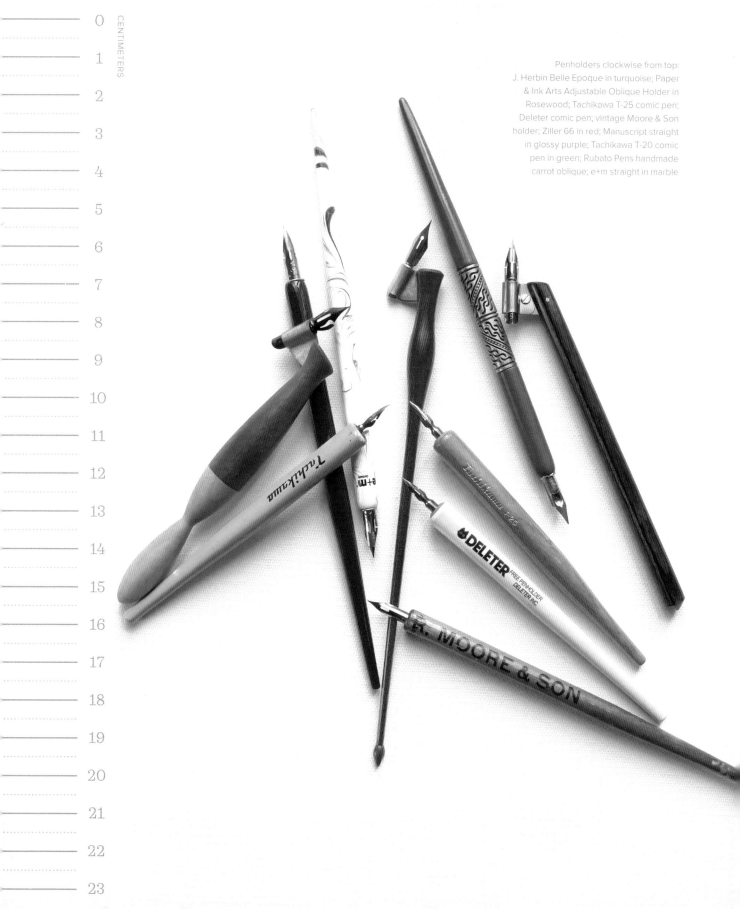

Penholders clockwise from top:
J. Herbin Belle Epoque in turquoise; Paper
& Ink Arts Adjustable Oblique Holder in
Rosewood; Tachikawa T-25 comic pen;
Deleter comic pen; vintage Moore & Son
holder; Ziller 66 in red; Manuscript straight
in glossy purple; Tachikawa T-20 comic
pen in green; Rubato Pens handmade
carrot oblique; e+m straight in marble

APPENDIX II

Glossary

This is a guide to the vocabulary used throughout the book, as well as to some of the most common calligraphy and typography terms that all calligraphers should know.

Aperture

The opening of an open counter, such as the one at the top of u and bottom of n.
Related: Counter

Apex

The point at the top of a letter where two strokes meet or part ways, such as the top of an A.
Related: Vertex

Ascender

The vertical portion of a lowercase letter that extends above the x-height to the ascender line.
Related: Ascender space, Ascender line, Cap height

Ascender line

The invisible line up to which a lettering style's ascenders extend. When ascenders are the same height as the uppercase letters, then the ascender line and cap height are the same.
Related: Ascender space, Cap height

Backhand

a.k.a. reverse italic
A writing style slanted to the left rather than the right.

Baseline

The line—usually imaginary—upon which letters sit. An alphabet's descenders fall below the baseline. While baselines are generally horizontal, they can be curved or slanted for effect.

Bowl

A fully closed, rounded part of an upper- or lowercase letter, such as in D and d.

Breather hole

a.k.a. vent hole
The hole in the center of a pointed nib. It serves the important purpose of preventing the slit between the two tines from cracking all the way down the nib's body when pressure is exerted.
Related: Tines

BREATHER HOLE

TINES

Broad tip

a.k.a. broad edge
A calligraphy nib with a flat, chiseled edge, creating thick vertical strokes and thin horizontal ones.

Cap height

The height of a capital letter, starting from the baseline. In some lettering styles and typefaces, the capital and ascender heights are the same, but certainly not always.
Related: Ascender line

Cardinal number

A number that represents a quantity (e.g., 1, 25) rather than a rank (e.g. 1st, 25th).
Related: Ordinal number

Comic pen

A penholder originally created for Japanese manga art. They tend to be straight, relatively short, and very lightweight. Tachikawa is the brand of comic pens most popular among calligraphers.

Compound curve

A double curve in the upstroke-downstroke-upstroke pattern. When an overturn is followed immediately by an underturn, the resulting shape is a single compound curve.
Related: Overturn, Underturn

Connector stroke

A hairline upstroke that exits one letter to connect to the next.

Crow quill pen

A tubular steel nib that can produce some of the thinnest and thickest strokes. Generally these nibs are extra small and require a special type of very thin holder.

Descender

The vertical portion of a lowercase letter that extends below the baseline to the descender line.
Related: Descender space, Descender line

Downstroke

A stroke created by the downward motion of a pen. In pointed pen work, pressure is exerted on downstrokes to produce thick swells.
Related: Swell, Upstroke

Entry stroke

A hairline upstroke that leads into a letter. When not beginning a word, it is both an entry stroke to one letter and a connector stroke between two.
Related: Connector stroke, Exit stroke

Exit stroke

The hairline upstroke at the end of a letter. When one letter's exit stroke leads into another letter, it becomes the connector stroke between the two.
Related: Connector stroke, Entry stroke

Ferrule

The metal ring at the end of some straight pen holders with four petal-like prongs that hold the nib in place.

Flange

The attachment to an oblique holder that forces the nib to point at a slant. They are usually made of metal.

Florid

Highly ornate, decorative, and elaborate; frequently used to describe flourished calligraphy.

Flourish

A decorative stroke that, when added to a letter, enhances and embellishes its basic form.

Folded pen

a.k.a. cola pen

A dip pen made from a folded piece of metal affixed to a straight stick (usually wood). These are easy to make at home with the metal from a soda can (hence their other name, "cola pens") and a chopstick or unsharpened pencil. The strokes that folded pens produce vary wildly depending on the shape created by the fold. Generally folded pen work has a carefree, irregular, bold appearance.

Font

Hand lettering styles are not fonts! Ever. This is one of the most misused terms in the type and lettering world. A font is a subset of a typeface, denoting a particular size, style, and weight. For example, Sagona is a typeface designed by René Bieder, and 12pt Sagona Extra Light is a font in the Sagona family (and it's the one used for the headers in this glossary). Traditionally fonts were made from metal or wood, but today fonts are most commonly digital.
Related: Typeface

Frisket

a.k.a. masking fluid, drawing gum

A thin fluid used to mask out areas of a drawing surface. Once dry, it can be removed with a rubber cement pick-up or by gently rubbing it with your finger

FRISKET (*a.k.a.* MASKING FLUID)

to reveal the paper underneath. Some brands, such as Pebeo, can be used with a dip pen to create calligraphy that looks like it cuts through paint you apply over it.

Gilding

The process of applying gold leaf, frequently used in illuminated letterforms and manuscripts.
Related: Illumination

Glyph

An individual character in an alphabet set. In addition to all the upper- and lowercase letters, glyphs can be accented characters, punctuation marks, symbols, numbers, and ligatures.
Related: Grapheme, Ligature

Grapheme

"Glyph" and "grapheme" are often used interchangeably, but there is an important difference. Graphemes are the smallest distinct units of written language, including accent marks and punctuation. À, for example, is a single glyph, but it is *two* graphemes.

Gum arabic

a.k.a. gum acacia
A substance made from the sap of acacia trees and used by calligraphers to adjust ink and paint viscosity, as well as to prepare nibs. As a binding agent, it helps color flow smoothly and also adds a glossy sheen. Sold as a liquid and powder (which should be mixed with distilled water).

Hairline

A very fine stroke produced by a pen. The width of a hairline is determined by the size of the pen's tip.
Related: Upstroke

Illumination

The art of decorating a calligraphed design or manuscript with extravagant illustrations, borders, and patterns, usually involving paint and gold leaf.
Related: Gilding

Ink cage

a.k.a. ink reservoir
Small, coiled metal attachments that fit in the concave side of pointed nibs, allowing the nib to hold more ink.

Kerning

The action of adjusting letter spacing to achieve the most visually satisfying composition. In calligraphy, kerning can be done when refining sketches or adjusting scanned art on the computer.

Laser liner

a.k.a. slide writer
A writing surface with an affixed laser that projects straight lines. These are used by calligraphers to assist with even baselines and spacing.

Layout bond

A smooth paper that is slightly heavier than traditional tracing paper. It is excellent for practice because the translucent variety lets guide sheets show through.

Leading

The distance between the baselines of two rows of text. The origin of this

word comes from the strips of lead ty-pographers used to separate rows of letterpress type. (Rhymes with "sledding," not "seeding.")

Letterform

The shape of a letter as it appears in a specific lettering style or font. For example, an A in one style can have a different form from A in another, even though they are the same letter.

Ligature

A single glyph created by the joining of two or more letters, commonly used when the disconnected letters would awkwardly bump into one another, such as fi, or when the letters very commonly appear together, such as qu and th.
Related: Glyph

Light pad

a.k.a. light box, light table
An illuminated writing surface used for tracing or seeing guide sheets through writing paper. The best ones have adjustable LED lights, making them easy on the eyes when used for long periods, day or night.

Loop

An enclosed bowl which is part of an ascender or descender. In most script styles, loops are found in b, d, f, g, h, j, k, l, p, q, and y.

Majuscule

An uppercase letter, a.k.a. capital letter.

Minuscule

A lowercase letter.

Monoline

a.k.a. monoweight
Lettering where the strokes have a uniform weight, rather than contrasting thin and thick strokes. Monoline calligraphy nibs come in a range of sizes and shapes, but their commonality is that pressure exerted on the nib does not change the stroke weight.

Negative space

The empty space, or background, that encompasses a composition. Negative space is an important design element because it defines the positive space (i.e., the composition's subject). Lots of negative space, such as wide margins, can create elegance and balance.

Oblique pen

A pen with an angled flange affixed to the writing end, which forces the nib to point at an angle which can be hard to achieve using a straight holder. Oblique penholders are primarily used by right-handed, pointed pen calligraphers, however they can be used by left-handed calligraphers, too.

Ordinal number

A number denoting rank, such as 1st or 50th.
Related: Cardinal number

Overturn

A curved, calligraphic stroke that moves up then down, as in the curved part of lowercase n.
Related: Compound curve, Underturn

Pangram

A sentence that uses every letter of the alphabet at least once; e.g., "A quick brown fox jumps over the lazy dog."

Shade

A thick downstroke that adds weight to a letter. The heavier the shading, the bolder the letter is.
Related: Swell

Slant

a.k.a. axis, slope, italic slant
The angle of the main axis of a lettering style, often measured by drawing an imaginary line between the points where a lowercase o touches the baseline and the x-height line. A highly varied slant is one trait of many modern calligraphy styles.

Stem

A letter's main, vertical downstroke(s). The letter k has one, h has two, and m has three.

Sumi ink

A traditional Japanese ink, very popular among calligraphers, made from soot, water, and a binding agent, such as glue or egg white. Some contain shellac to make them waterproof.

Swell

The thick part of a downstroke where the stroke "swells" from thin to thick and back to thin again.
Related: Shade

Tail

The trailing exit stroke of a letter. Tails can be part of a letter's basic anatomy, such as the cross stroke of Q, but they can also be at the ends of words, like a swash added to a final e.

Tines

The two symmetrical metal pieces that come together to form the point of a pointed nib. Tines extend from the nib's tip to its breather hole, where the split between the tines ends.
Related: Breather hole

a quick brown fox jumps over the lazy dog.

Tooth

A paper's surface quality is described in terms of its tooth. The greater the tooth, the greater the texture.

Typeface

a.k.a. type family, font family
A particular design of type that contains subsets called fonts. For example, Proxima Nova is a typeface designed by Mark Simonson. Within its type family are individual fonts, such as 10pt Proxima Nova Light (what you're reading right now). While calligraphic styles are never referred to as typefaces or fonts, it is important for lettering enthusiasts to use the terms correctly.
Related: Font

Underturn

A curved, calligraphic stroke that moves down then up. The curved part of lowercase u is an underturn.
Related: Compound curve, Overturn

Upstroke

A stroke created by the upward motion of a pen. In pointed pen work, pressure cannot be exerted on the nib when it's moving up, left, or right, and therefore in

all these directions, the resulting stroke is a hairline.
Related: Downstroke, Hairline

Vellum

A type of parchment made from animal skin, usually that of a calf, lamb, or goat. Vellum dates back to Ancient Egypt, however today there are also forms of paper vellum, which are normally very strong and translucent, and come in a range of colors. Papers with a "vellum finish," however, are not themselves vellum. It just means they are uncoated and have a subtle tooth.
Related: Tooth

Vertex

The point at the bottom of a letter where two strokes meet or part ways, such as the bottom of a V.
Related: Apex

Waistline

The invisible line up at the top of a lettering style's x-height space.
Related: x-Height

Weight

A descriptor for the relative thickness (i.e. boldness) of a stroke or letter. Hairlines have almost no weight, whereas downstrokes can be very heavy. The ways to control the weight of calligraphic strokes are to use a different nib or exert more pressure on the nib.

x-Height

The x-height of a font or hand lettering style is the height of its lowercase x. All letters of the alphabet, both upper- and lowercase, occupy the x-height space. Lowercase letters without ascenders or descenders sit *only* within this space (e.g., a, m, o, x), between the baseline and waistline.
Related: Ascender, Descender, Waistline

Diacritical Marks

Áá	Acute, a.k.a. apex
Ğğ	Breve
Řř	Caron
ÇÇ	Cedilla
Ââ	Circumflex
Öö	Diaeresis, a.k.a. umlaut
Ġġ	Dot
Őő	Double acute
Àà	Grave
Ēē	Macron
Øø	O stroke
Ųų	Ogonek
Åå	Overring
Ññ	Tilde

Special Characters

Ææ	Æsc, a.k.a. ash
&	Ampersand
℅	"Care of"
«»	Double-angle quotations, a.k.a. guillemets
…	Ellipsis
—	Em dash
–	En dash
ß	Eszett, a.k.a. German sharp s
☙	Fleuron, a.k.a. hedera
-	Hyphen
‽	Interrobang
¡	Inverted (or opening) exclamation point
¿	Inverted (or opening) question mark
№	Numero sign
¶	Pilcrow, a.k.a. paragraph sign
§	Section mark

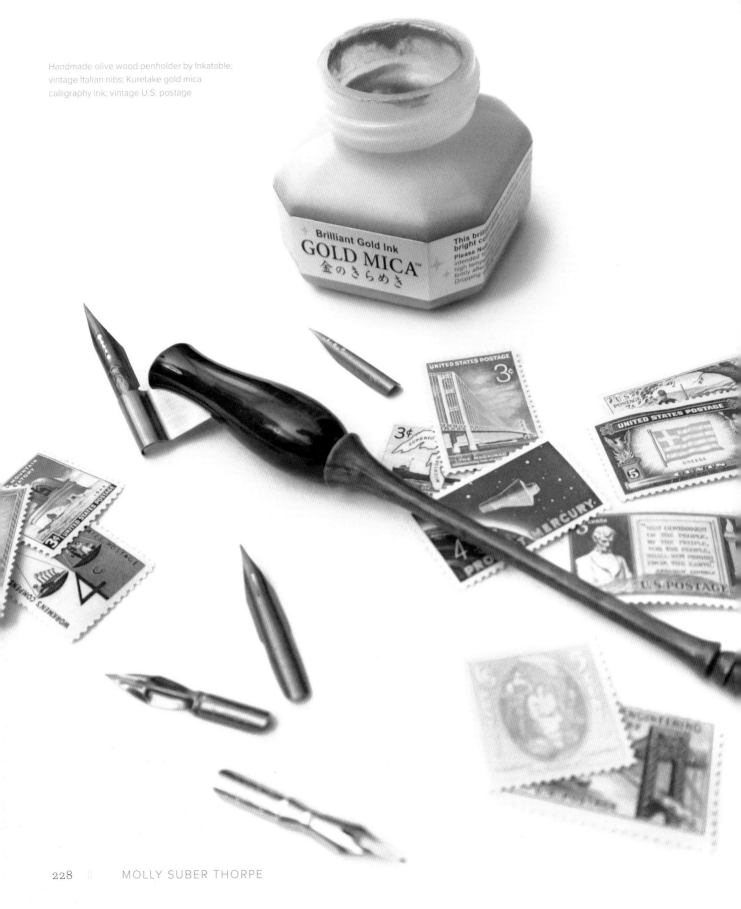

Handmade olive wood penholder by Inkatable;
vintage Italian nibs; Kuretake gold mica
calligraphy ink; vintage U.S. postage

Additional Resources

The most common questions I get are about where to shop for calligraphy supplies in various corners of the world, techniques for digitization, networking with other calligraphers, and how to get a freelance calligraphy business up and running. Here I provide some of my favorite resources that can help with all these things.

SHOPPING *for* SUPPLIES

These are just a sampling of my favorite shops and makers of handmade, vintage, and custom supplies. For an even longer list, visit my link archive at Calligrafile.com.

Calligraphy Supply Stores

Blue Pumpkin
bluepumpkin.ru • Russia

Calli Art
kalligrafie.com • Netherlands

Calligraphy Store
calligraphystore.it • Italy

Calligraphy Supplies Australia
calligraphysuppliesaustralia.com • Australia

Comptoir des écritures
comptoirdesecritures.com • France

The Craft Central
thecraftcentral.com • Philippines

Curry's
currys.com • Canada

Federführend
feder-fuehrend.de • Germany

Jet Pens
jetpens.com • United States

John Neal Bookseller
johnnealbooks.com • United States

Kaligraf
calligraphers.eu • Poland

Kalligraphie
kalligraphie.ch • Switzerland

Not Just A Card
notjustacard.com • Australia

Paper & Ink Arts
paperinkarts.com • United States

Paper Tree
papertree.jp • Japan

Penman Direct
penmandirect.co.uk • United Kingdom

Scribblers
scribblers.co.uk • United Kingdom

Scribe
scribeph.com • Philippines

Splendith
splendith.nl • Netherlands

Paper

Fabulous Fancy Pants
fabulousfancypants.com • United States

Mulberry Paper
mulberrypaperandmore.com • United States

Papeterie Saint-Armand
st-armand.com • Canada

Handmade Penholders

Ash Bush
ashbush.com • United States

Bukva Wood
bukvawood.ru • Russia

Chic Oblique
chicoblique.co.uk • United Kingdom

The Curious Artisan
thecuriousartisan.com • Philippines

Huy Hoang Dao
huyhoangdao.com • Vietnam

Inkatable
inkatable.etsy.com • Italy

Ink Slinger Pens
inkslingerpens.com • United States

Jaay Pens
jaaypens.etsy.com • United States

Jake Weidmann
jakeweidmann.com • United States

Lindsey Hook
lindsey-hook.com • United States

Oblique Pen
obliquepen.ru • Russia

Rolf Pens
rolfpens.etsy.com • Spain

Rubato Pen
rubatopen.etsy.com • United States

Tom's Studio
tomsstudio.co.uk • United Kingdom

Troyan Pen
troyanpen.etsy.com • Ukraine

Unique Oblique
uniqueoblique.com • United States

Yoke Pen Company
yokepencompany.com • United States

Postage Stamps

Art Stamped
artstamped.etsy.com • United Kingdom

Verde Studio
verdestudio.etsy.com • United States

Rubber Stamps & Wax Seals

The English Stamp Company
englishstamp.com • United Kingdom

RubberStamps.net
rubberstamps.net • United States

Stamptitude
stamptitude.com • Hong Kong

Miscellany

Calligraphity—books
calligraphity.com • Scotland

Design Kous—ink & inkwells
designkous.com • Mexico

Etsy
etsy.com • Global

Fox & Quills Apothecary—ink
foxandquills.etsy.com • United States

Sew Darn Close—pen rolls
sewdarnclose.etsy.com • United States

Warm Ceramics —pen rests
warmceramics.etsy.com • Russia

MEET OTHER CALLIGRAPHERS

Join a calligraphy guild or attend a calligraphy conference! Your local guild likely offers classes and presentations at affordable prices, so you can network with local peers and learn new techniques.

Although it's growing rapidly, the global calligraphy community is still relatively small. I'm proud to say it's one that values community over competition, and that most calligraphers aren't more than one degree of separation away from one another, so you should never feel nervous to reach out to a fellow lettering artist to say hello.

Calligrapher Joy Deneen has compiled links to conferences and guilds worldwide, as well as to scholarships available to calligraphers, at calligrafile.com/guilds-conferences-museums.

SKILLSHARE

Skillshare.com is an online learning platform offering excellent courses in art, design, photography, and business. Many talented lettering artists teach on Skillshare, each with unique styles and special techniques to pass on to their students.

I teach a handful of classes on Skillshare aimed at digital hand lettering, including Digitizing Calligraphy from Sketch to Vector and Mastering iPad Lettering. You can learn more about these, and how to get a discounted membership, at mollysuberthorpe.com.

BUILD A LIBRARY

Keeping yourself inspired is the most fulfilling way to continue producing fresh new work. Slowly build a library of beautiful lettering books—whether they are about sign painting, illuminated manuscripts, Gothic calligraphy, or digital typography—to provide a steady stream of inspiration.

I also have two other books that may help you in your calligraphy journey. *The Calligrapher's Business Handbook: Pricing and Policies for Lettering Artists* is a freelancer's companion, sharing all the ins and outs of a successful calligraphy business. And for hands-on project ideas (or a refresher on the basics), *Modern Calligraphy: Everything You Need to Know to Get Started in Script Calligraphy* is a guide for beginners to pointed pen.

For a long list of lettering books I have in my own library, visit calligrafile.com/books-magazines.

Supply Kit Recommendations

Digital Lettering Tools

Online Learning Resources

In-person Learning Resources

Guild Network Directory

Print & Web Design Help

Inspiring Artist Stories

Social Media & Advertising Tools

Downloadable Assets

Freelancer Resources

CALLIGRAFILE.COM

alligrafile.com is a curated library of trusted tools and resources for calligraphers, hand lettering artists, type enthusiasts, and creative freelancers. I launched the site in 2016, when I teamed up with over a dozen other professional lettering artists to build the site's archive: 500+ recommended products and services in dozens of categories. Calligrafile is the largest resource of its kind—and it's completely free—making it an exciting and valuable tool for anyone who loves and works with letters, from the professional artist to the weekend hobbyist.

ABOUT *the* AUTHOR

Molly Suber Thorpe works as a professional calligrapher, freelance graphic designer, and teacher. She specializes in hand-lettered logo designs and calligraphy for publications.

Molly achieved renown for her bestselling book, *Modern Calligraphy: Everything You Need to Know to Get Started in Script Calligraphy* (St. Martin's Griffin, 2013), a beginner's guide covering the basics of pointed pen lettering. She became credited as a driving force behind the modern calligraphy movement, being among the first artists to use the whimsical, unorthodox pointed pen styles and bold color palettes so popular today. Clients hire Molly for a variety of projects, including hand-lettered logos, envelope calligraphy, custom stationery, and even tattoos.

Modern Calligraphy has been translated into Chinese and Spanish, and was named one of 2013's "Favorite Craft Books" by Amazon. Her second book, *The Calligrapher's Business Handbook: Pricing and Policies for Lettering Artists* (2017), guides hand letterers to develop a thriving freelance career, and has been an Amazon Bestseller in the Calligraphy and Business of Art categories.

Molly's extensive client list includes Google Arts & Culture, *Martha Stewart Weddings*, Michael Kors, Fendi, AARP, J. Jill, and Victorio & Lucchino. Her work and words have appeared in dozens of publications, including *UPPERCASE, Martha Stewart Living, The Wall Street Journal, LA Times, The Guardian, Buzzfeed, Bound & Lettered, Country Living, Style Me Pretty, Design*Sponge,* and *Snippet & Ink*.

Molly also loves to teach. In addition to conducting in-person calligraphy workshops in the United States and Europe as her time permits, Molly has been named a Top Teacher on the Skillshare.com platform, with over half a million minutes of watch time since her first Skillshare class launched in 2013.

In 2016, Molly founded Calligrafile.com, a curated database of resource links and products for calligraphers, hand lettering artists, type enthusiasts, and creative freelancers. It is the largest site of its kind, with over two dozen contributing artists, and thousands of participants from around the world.

Angela Liguori, Studio Carta

Molly graduated from UCLA's Design Communication Arts program in 2009 with a concentration in typography and layout design. Before UCLA, she studied art history, comparative literature, and creative writing at The American University of Paris. After spending nearly a decade in Los Angeles, Molly now lives in Athens, Greece. She works with clients all over the world, from New York to Paris to Cape Town to Taipei. A true Francophile, Molly looks forward to the day she may once again live in Paris.

Acknowledgments

First and foremost, thank you to my calligraphy students, who provided years of questions and feedback that served as the basis for this book. I couldn't have finished it, though, without my agent, Lindsay Edgecombe, whose support and nudges are the reason all my books have gone from concept to completion. My editor, Daniela Rapp, trusted me from the start, giving me complete creative license, which has made this project one of the most fulfilling of my career. My partner, Ektor, has my gratitude for bringing me coffee when I worked late, then bringing me more when I started my day. If my cat could read this, he would also want thanks for providing daily entertainment, keeping my chair and papers warm, and only leaving paw prints on one piece of artwork.

Molly Suber Thorpe

Learn more about Molly:

mollysuberthorpe.com

Follow Molly on social media:

@mollysuberthorpe

Join the community by tagging your work:

#masteringmoderncalligraphy